IMAGES
of America
WESTLAND

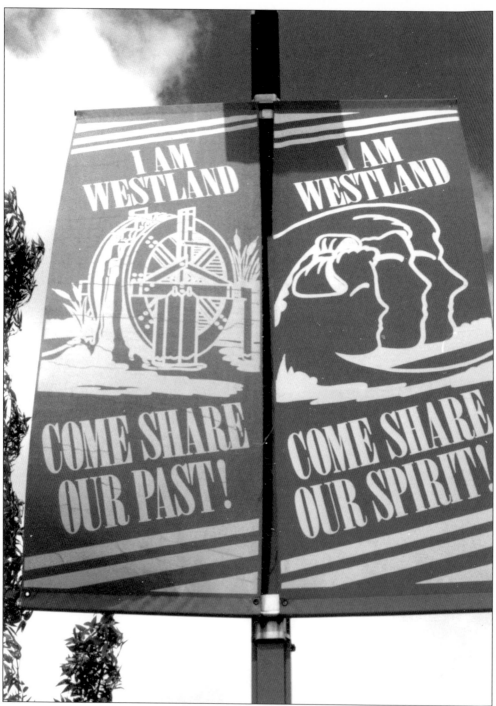

These banners celebrate Westland's motto: "Westland, City of Pride, Progress, and Promise." Those who live in Westland can take pride in the city's history. Much progress has been made taking Westland from an untamed wilderness to one of Michigan's largest cities. Westland also has the promise of new challenges to face and overcome. (Courtesy of the Westland Community Relations Department.)

IMAGES
of America
WESTLAND

Daryl Alan Bailey and Sherrye Louise Huggins Bailey

ARCADIA

Published by Arcadia Publishing,
an imprint of Tempus Publishing, Inc.
Charleston SC, Chicago, Portsmouth NH,
San Francisco

Printed in Great Britain.

Library of Congress Catalog Card Number: 2004101698

For all general information contact Arcadia Publishing at:
Telephone 843-853-2070
Fax 843-853-0044
E-Mail sales@arcadiapublishing.com
For customer service and orders:
Toll-Free 1-888-313-2665

Visit us on the internet at http://www.arcadiapublishing.com

The authors wish to dedicate this book to the unrelenting pioneering spirit that built this great city. We also wish to dedicate this book to the loving memory of Louise Mayo and Bobbye Louise Huggins.

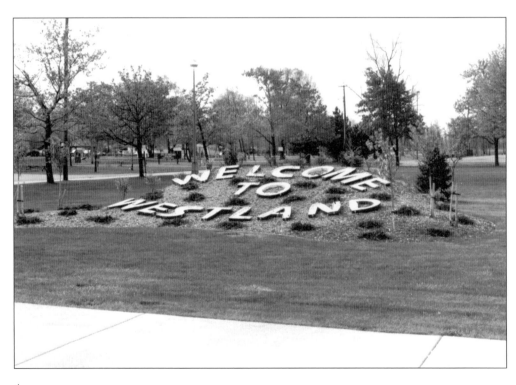

CONTENTS

ACKNOWLEDGMENTS

The authors would like to acknowledge those that have assisted in the creation of this book. First we would like to thank Valerie Latzman and Virginia Presson, of the Wayne Historical Museum, for not only providing many of the images that appear in this book, but also for their support and encouragement throughout the project.

Special thanks go to the following individuals and groups: to Carol Clements, the Naturalist at the Nankin Mills Interpretive Center, she has been very supportive of this project and provided many of the images of Nankin Mills; to Ford Motor Company who provided us with images of their founder, Henry Ford I, and his wife, Clara Ford; to Ford retiree, Tim O'Callaghan, and Linda Leggitt, a current Ford employee, for their support and contributions; to Richard Andrews, of the Wayne Historical Society; to Virginia Braun, Ruth Dale, and Eric J. Rasmussen, of the Friends of the Westland Historical Museum; to William Branton, former member of Company 1618, Civilian Conservation Corps; to Jane Eva Baxter, Associate Professor of Anthropology at DePaul University—her work at the Westland Historical Museum has shed new light on the history of the Felton Farmhouse and the City of Westland; to Craig Welkenbach, of the Westland Community Relations Department; to the Honorable Sandra Cicirelli, mayor of Westland; and to Maura Brown, of Arcadia Publishing, for her support and guidance throughout the process.

Special acknowledgments go to our two children, Sarah and James, for their patience, love and support, and to our grandson Kyle.

INTRODUCTION

The City of Westland is a mere 38 years old and it has had a long and colorful journey. The city occupies roughly 22 square miles of Western Wayne County, just outside the city of Detroit, Michigan. However, this little piece of real estate has changed hands several times in the past several hundred years and has experienced numerous forms of local government, some of which occurred before Michigan became a state.

Before the advent of White Europeans, this land was the hunting grounds for various Native American tribes including the Sauk, the Miami, and the Potawatomi. Warriors of the Sauk tribe created the paths that would one day become Michigan Avenue. Michigan Avenue, formerly known as the Chicago Military Road, connected Detroit with Chicago, Illinois. In the 1640s the Iroquois Nation, an ally of the British Empire, invaded and drove all the Michigan tribes out of the state. These displaced tribes allied themselves with the French and eventually reclaimed their hunting grounds. For many years these 22 square miles were part of the French holdings in North America.

Later the British and French would fight for control of the region. This was known as the French and Indian War. As a result of the French defeat in this war, the 22 square miles along with all the land north of the Ohio River and east of the Mississippi became part of the British Empire. Following the Treaty of Paris in 1783 ending the American Revolution, this land was ceded to the United States of America. It became known as the Northwest Territory. While now a part of the United States, British troops maintained several garrisons in the Northwest Territory until 1796.

The sale of public land, including the Northwest Territory, was to be done in accordance with the Land Ordinance of 1785. Before the land could be sold, the government had to have clear title to the land. In 1807 the Treaty of Detroit was signed. As a part of the treaty, the Native America tribes sold the United States most of Southeast Lower Michigan, including these 22 square miles.

Tonquish, a chief of a Potawatomi tribe, was a signer of the 1807 Treaty of Detroit. This treaty provided him and his tribe with a reservation of two miles along the upper Rouge River. The tribe could continue to hunt in the ceded lands as long as it was still owned by the federal government. In the fall of 1819, an altercation over some freshly baked loaves of bread took the life of a white pioneer named Sergeant, Chief Tonquish, and his son. The two Potawatomi warriors were buried in the northern portion of the 22 square miles.

Pioneers began to settle this region in the 1820s. Some of those pioneers included George Johnson, William Osband, Glode Chubb, and the Reverend Marcus Swift. As the population began to grow, townships were created. In 1827 Bucklin Township was established. It consisted of the current cities of Westland, Wayne, Garden City, Inkster, Livonia, Dearborn and Dearborn Heights, and the Township of Redford.

By 1829, the population had grown enough to divide Bucklin Township. Originally these two new townships were to be called Lima and Richland, but there was a law on the books that said that a new post office could not have a name used somewhere else in the country. New names would be needed. At that time the newspapers were covering Christian missionaries in China. Officials decided to call the new townships Nankin and Pekin in honor of the Chinese cities of Nanking and Peking. These 22 square miles were now part of the southern half of Nankin Township. In 1835, population growth caused the division of Nankin Township. The southern half of the township retained the name Nankin, while the northern half took the name Livonia Township, named for a region of Russia along the Baltic Sea.

During the early years of Nankin Township, several small, unincorporated villages began to appear within its borders. In the southern part of the township, along the Chicago Military Road, grew the Village of Derby Corners. It was named for Ezra Derby who had purchased a large plot of land in 1832, subdivided it, and sold the individual lots. This village would later become the Village of Wayne. Meanwhile, in the northern part of Nankin Township was the Village of Perrinsville. This village was named for the Perrin brothers, Abraham and Isaac, and grew along the Territory Road, which connected Detroit with Ann Arbor. Today this road is known as Ann Arbor Trail. In the beginning, the Territory Road was a better road for travelers and the Village of Perrinsville thrived until 1837, when the railroad by-passed the village, choosing to go through the Village of Wayne. In 1857 the small village of Moulin Rouge (French for "red mill") was established in the eastern part of Nankin Township. In 1863, the name was changed to Inkster in honor of Robert Inkster would owned a sawmill along the lower branch of the Rouge River.

Political divisions took their toll on Nankin Township. In 1869 the Village of Wayne was incorporated and became the base of political power within Nankin Township. Some residents in the northeastern part of the township wished to have their own identity and the incorporated Village of Garden City was established in 1927. That same year the Village of Inkster was also incorporated. In 1933, the residents of the Village of Garden City took another step and incorporated as the City of Garden City. The year 1958 saw the Village of Wayne try to incorporate as a city of 12 square miles. This was rejected by the voters of Nankin Township by a margin of a mere nine votes. Two years later the Village of Wayne tried again to incorporate as a city. This time, the proposed city would be just six square miles. In 1960, Nankin voters approved the proposal and the City of Wayne was born.

Official groundbreaking for the Westland Mall was held on July 17, 1963. The City of Livonia, which had incorporated as a city in 1950, eyed seven square miles of Nankin Township, including the mall, as ripe for annexation. Many of the residents of Nankin opposed the annexation and the race was on to incorporate as a city. Because saving the Westland Mall from Livonia became a rallying cry, the proposed name of the city was Westland.

The year 1964 saw Nankin voters approve a Westland City Charter Commission and the incorporation of Inkster as a city. Nankin voters approved the Westland City Charter and the City of Westland came into existence at 8:00 p.m. on May 16, 1966.

In this publication we will explore this journey. It is a centuries-old journey from Native American hunting grounds and pioneer wilderness to the present-day city of Westland, Michigan.

One
VILLAGES AND CORNERS

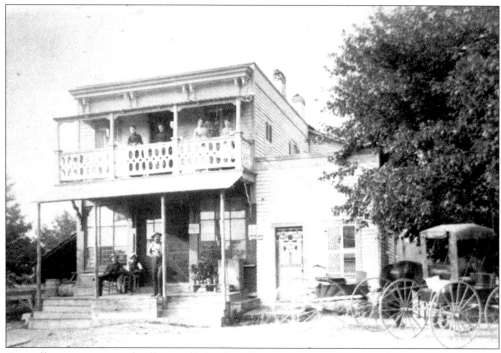

A small, unincorporated village called Pike's Peak grew up around Nankin Mills in the mid-1800s. Legend has it that the village received its name because the miller, Martin Shepard, had been in Pike's Peak, Colorado, during the gold rush. At one time the village consisted of Nankin Mills, a blacksmith shop, a general store (shown here), a post office, and a print shop. Like the other villages in what became Westland, Pike's Peak eventually faded into obscurity. (Courtesy of the Nankin Mills Interpretive Center archives.)

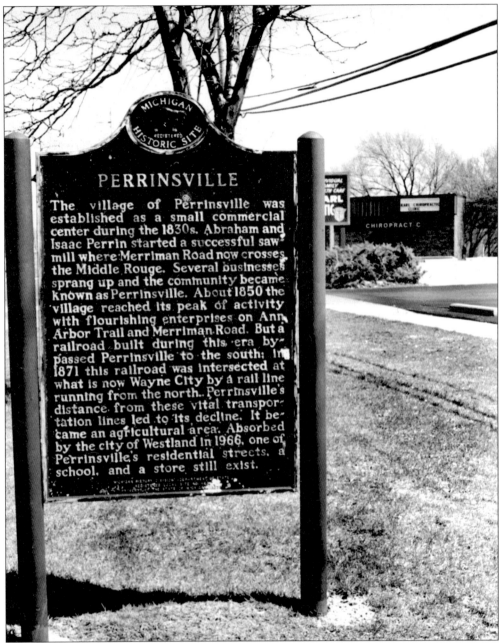

PERRINSVILLE

The village of Perrinsville was established as a small commercial center during the 1830s. Abraham and Isaac Perrin started a successful saw-mill where Merriman Road now crosses the Middle Rouge. Several businesses sprang up and the community became known as Perrinsville. About 1850 the village reached its peak of activity with flourishing enterprises on Ann Arbor Trail and Merriman Road. But a railroad built during this era by-passed Perrinsville to the south; in 1871 this railroad was intersected at what is now Wayne City by a rail line running from the north. Perrinsville's distance from these vital transportation lines led to its decline. It became an agricultural area. Absorbed by the city of Westland in 1966, one of Perrinsville's residential streets, a school, and a store still exist.

The Village of Perrinsville began to grow along what is now the intersection of Ann Arbor Trail and Merriman Road. It bore the name of two brothers, Abraham and Isaac Perrin, who moved to Nankin Township in 1832 from Monroe County, New York. In 1899, Melvin D. Osband recorded, "Such was Perrinsville in its prime about the years 1840 to 1850, a flourishing little village and bid fair to come into prominence. But from some cause it took a blight, and for many years past it has been fading, its mill and shops have been abandoned, and it now looks as though in a few years it will be as desolate as ancient Troy, and men will differ about its locality." The state historical marker shown here indicates its approximate location. (Courtesy of Daryl A. Bailey.)

The Hawthorne County Club, near the northeast corner of Warren and Merriman Roads, was the site of the Perrins' Sawmill. Two brothers, Abraham and Isaac Perrin, owned and operated the mill. (Courtesy of Daryl A. Bailey.)

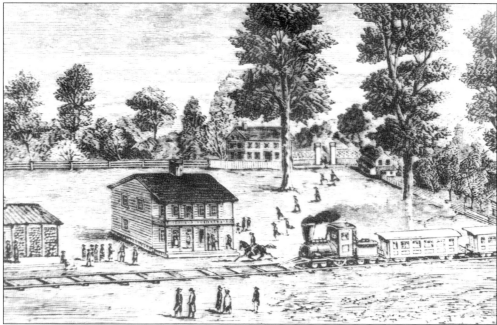

The first train arrived in the Village of Wayne on February 3, 1838. The decision to build the tracks through Wayne raised that village to prominence in Nankin Township and doomed the Village of Perrinsville. (Courtesy of the Wayne Historical Museum.)

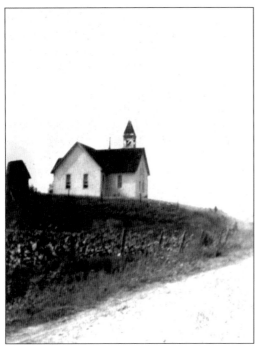

The Perrinsville Methodist Church, built in 1846, was located north of the Rouge River and east of Merriman Road in what was then the Village of Perrinsville. (Courtesy of the Wayne Historical Museum.)

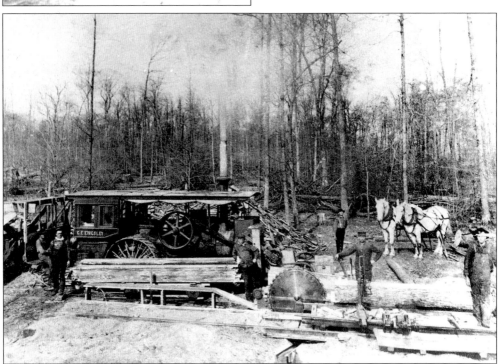

Sawmills sprang up early in the history of most Michigan communities. The villages of Wayne, Perrinsville, and Moulin Rouge (Inkster) each had a sawmill. The sawed lumber provided the building material for frame houses, barns, stores, and shops. These sawmills were excellent investments and provided employment for many residents. (Courtesy of the Wayne Historical Museum.)

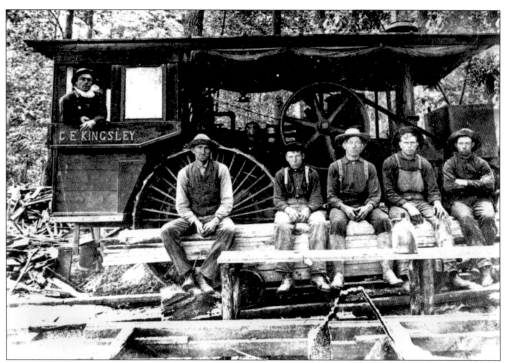

This steam tractor was used to power the C.E. Kingsley Sawmill. (Courtesy of the Wayne Historical Museum.)

The blacksmith played an important role in the life of every village. The clinks of their hammers could be heard from their shops. They performed many sundry jobs for their neighbors, including the repair of farm tools. (Courtesy of the Wayne Historical Museum.)

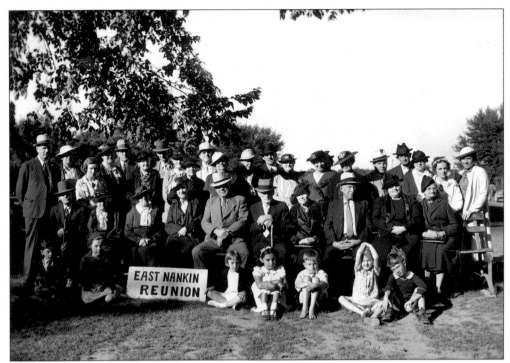

The area known as East Nankin, also called the Irish Settlement, included parts of what are now the cities of Westland, Garden City, and Redford. (Courtesy of the Wayne Historical Museum.)

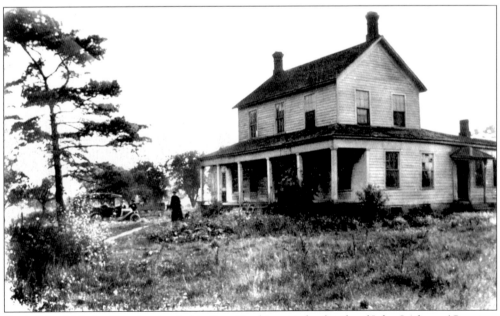

One of the Irish families that settled in East Nankin was the family of John Lathers. (Courtesy of the Wayne Historical Museum.)

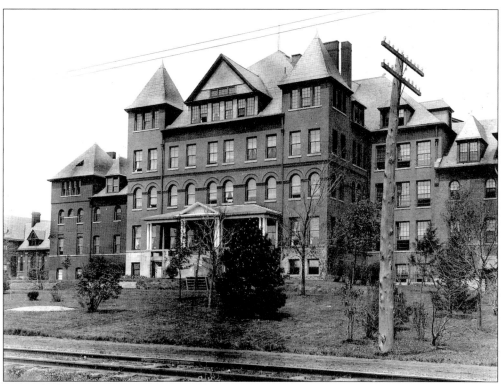

In April of 1839, Wayne County established a poor house near the corner of Michigan Avenue and Henry Ruff Road. It was know as the Wayne County House, and would become a poor house, an insane asylum, and county hospital. Over time it became a self-supporting community. The complex became known as Eloise, when on July 20, 1894, a post office called Eloise was opened on the complex. (Photograph courtesy of the Wayne Historical Museum.)

This is the asylum building and some of the grounds at Eloise. (Courtesy of the Wayne Historical Museum.)

In 1854 Robert Inkster purchased a sawmill located at what is now the intersection of Michigan Avenue and Inkster Road. In 1857 a village known as Moulin Rouge (French for "red mill") was established near the mill. In 1863 the village was renamed Inkster. It became a home-rule city in 1964. (Courtesy of the Wayne Historical Museum.)

The Kurtsell Saloon was located on Inkster Road in the Village of Inkster. (Courtesy of the Wayne Historical Museum.)

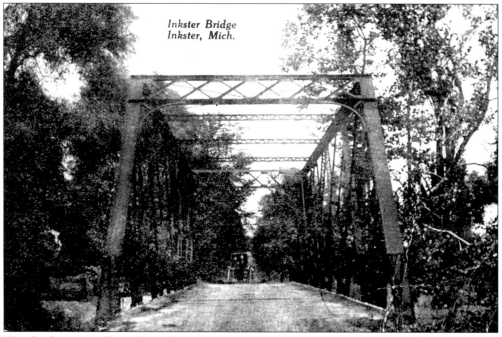

This bridge once allowed travelers to cross over the Rouge River in the Village of Inkster. (Courtesy of the Wayne Historical Museum.)

In 1824 George Johnson purchased 80 acres along what is now westbound Michigan Avenue, then known as the Chicago Military Road. There he built a log tavern. The Chicago Military Road was not, at that time, as good a route as the Territorial Road, now known as Ann Arbor Trial. In 1825 he sold the tavern and purchased 80 acres along the Territorial Road in what is now the northeastern part the City of Westland. Stephen S. Simmons purchased the tavern. In a drunken rage he killed his wife. On September 24, 1830, Simmons was the last man legally hanged in Michigan. (Courtesy of the Wayne Historical Museum.)

In 1832 Ezra Derby purchased the tavern from Simmons' sons. Derby subdivided part of this land and sold the lots. A small village grew there, known as Derby's Corners. The village was later renamed Wayne. It became a home-rule city in 1960. Ezra Derby is pictured here with his third wife, Hannah. (Courtesy of the Wayne Historical Museum.)

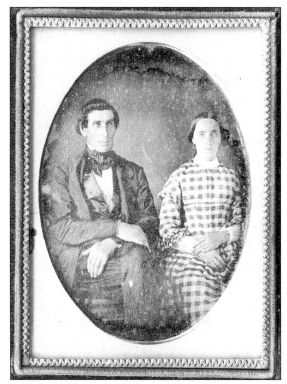

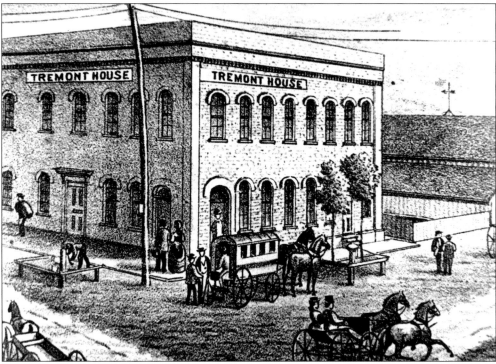

The Tremont House was a popular hotel in the Village of Wayne. (Courtesy of the Wayne Historical Museum.)

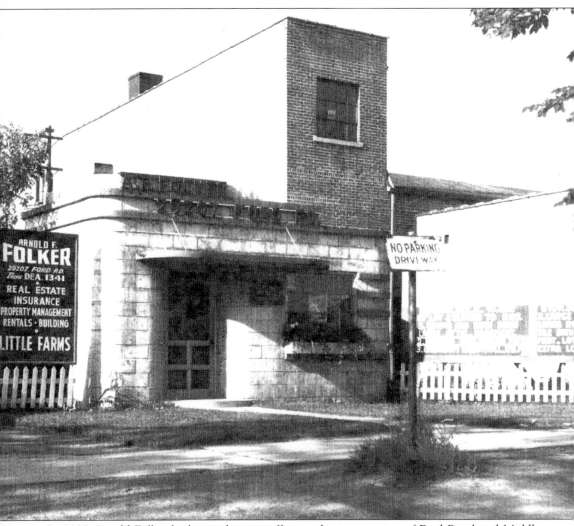

In 1923 Arnold Folker built a real estate office at the intersection of Ford Road and Middle Belt. This intersection became known as "The Corner." The Village of Garden City was formed in 1927, and "The Corner" became part its business district. In 1933 Garden City became a home-rule city. (Courtesy of the Garden City Historical Museum.)

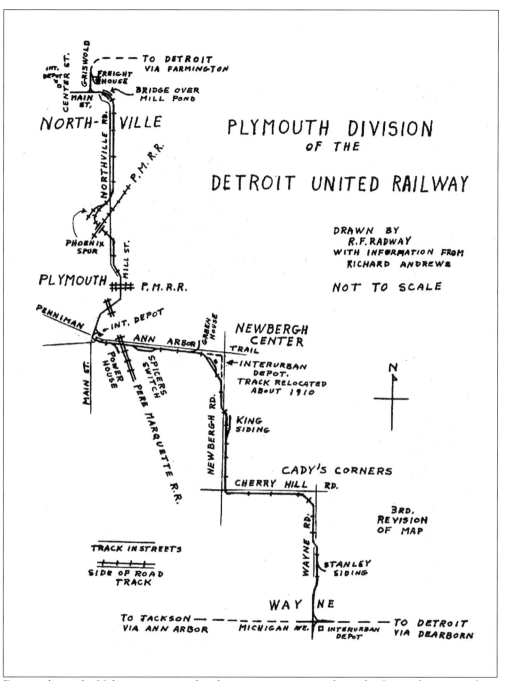

During the early 20th century, two local corners were stops along the Interurban route from Wayne to Plymouth. The intersection of Wayne and Cherry Hill Roads was once known as Cady's Corner. On the southwest corner was the site of the first Cady School building. The intersection of Newburgh and Warren Roads was once known as King's Corner. Here the King family had a dairy for many years. R.F. Radway drew this map from information provided by Richard Andrews. (Courtesy of Richard Andrews.)

Built in 1878, the Wayne Village Hall served as the seat of government for both the Village of Wayne and Nankin Township until the mid-1950s. In 1969, the building became the Wayne Historical Museum. (Courtesy of Daryl A. Bailey.)

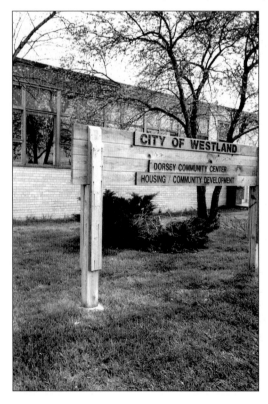

The Dorsey Community Center served as the Township Hall from the mid-1950s until April, 1964. (Courtesy of the Westland Community Relations Department.)

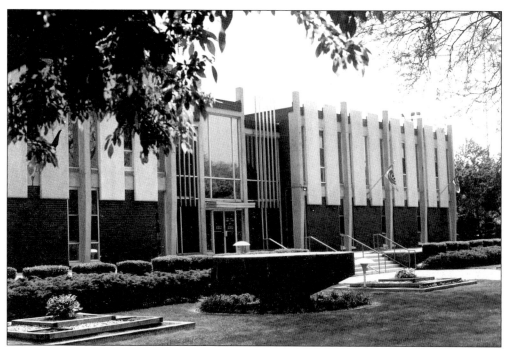

On April 20, 1964, the first Nankin Township meeting was held in the John F. Kennedy Memorial Building, now known as Westland City Hall. Westland became a city on May 16, 1966. (Courtesy of Daryl A. Bailey.)

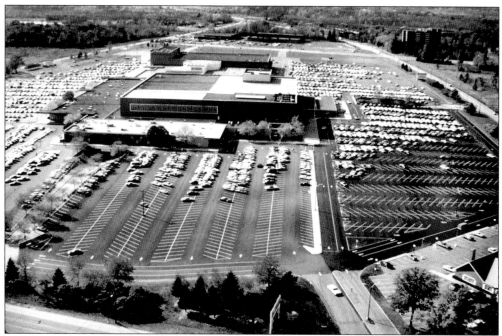

On July 17, 1963, the groundbreaking ceremony was held for the Westland Mall. The Mall's Grand Opening occurred on July 29, 1965. (Courtesy of the Westland Community Relations Department.)

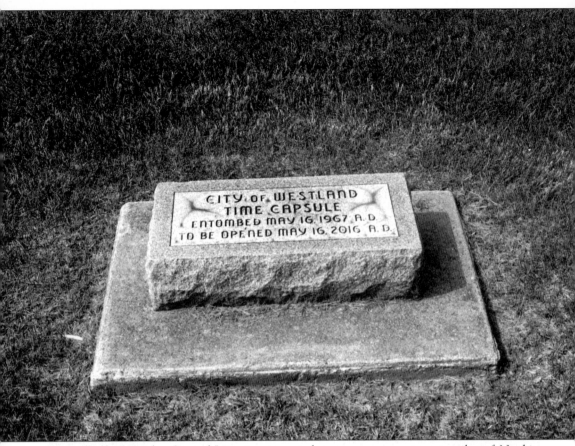

In April of 1963, the City of Livonia attempted to annex seven square miles of Nankin Township, including the site of the Westland Mall. Some Nankin Township political leaders organized a movement to incorporate the remaining part of Nankin Township as a home-rule city. To remind residents of what was at stake, the proposed city was called Westland. On May 16, 1966, the City of Westland was born. On May 16, 2016, as part of Westland's 50th birthday celebration, this time capsule, buried in front of the Westland City Hall, will be opened. (Courtesy of Daryl A. Bailey.)

Two

PIONEERS AND FARMERS

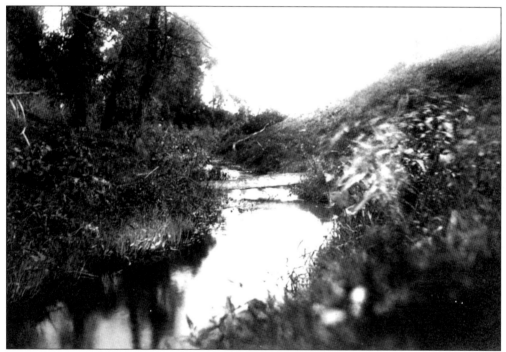

This is Tonquish Creek, named for the Potawatomi chief of the same name. In the fall of 1819, the chief, his son, and other warriors traveled down the Rouge River into what is now Dearborn, looking for food. There are several accounts of what happened next, but in the end, the chief's son killed a white man. The settlers quickly formed a posse and pursued the natives. They captured all the warriors except the chief's son. According to one account, a militia officer aimed his musket at the fleeing boy. Tonquish spoke and offered to call his son back. The chief called to the boy in their native tongue to continue running. When Tonquish thought the boy was out of musket range, he told the officer to go ahead and shoot. The musket ball cut through the air and killed the boy. The chief pulled out a knife he had hidden in his clothes and charged at the officer. A settler blocked the chief's progress while the officer reloaded. Tonquish saw this and began to run. The officer shot him in the back. (Courtesy of the Wayne Historical Museum.)

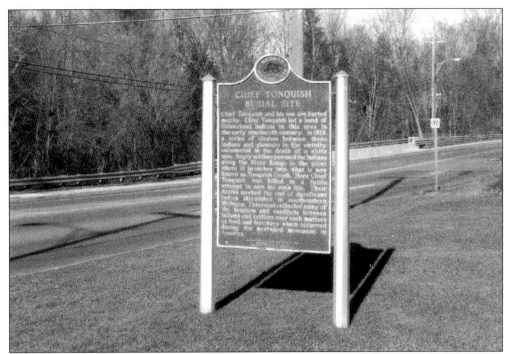

Near this site it is believed Chief Tonquish and his son were buried. Melvin D. Osband recorded, "About the year 1837–8 some boys opened the graves and took from them the chief's gun—or more properly gun barrel—and some personal ornaments." Years later a farmer plowed up this area to grow crops. (Courtesy of Daryl A. Bailey.)

Prairie schooner, about 1860

For many, the word pioneer brings to mind images of the prairie schooner. Many of the early Nankin pioneers did not arrive by prairie schooner, but came via the Erie Canal and a passage on a steamboat from Buffalo, New York, to Detroit. From Detroit they would head west either by walking or by wagon. (Courtesy of the Wayne Historical Museum.)

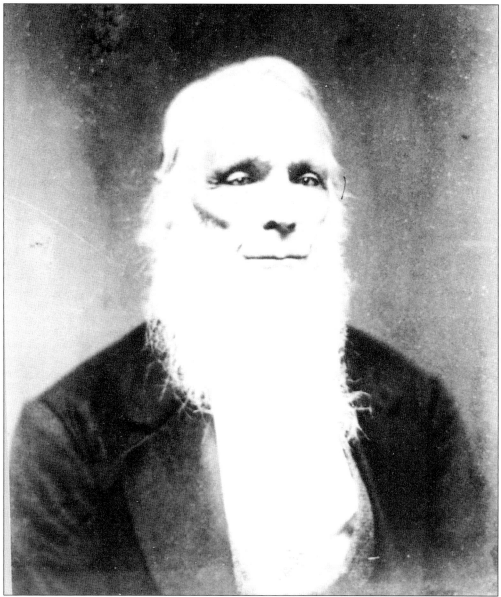

Glode Chubb arrived in Nankin Township in 1826. His farm was along what is now Warren Road west of Hix Road. In 1841 he joined with Reverend Marcus Swift and withdrew from the Methodist Episcopal Church. In 1853 he sold his farm and moved to what is now the northeast corner of Venoy and Michigan Avenue, south of the lower Rouge River. The lower Rouge River was a route for the Underground Railroad. Chubb, it is alleged, served as an agent of the Underground Railroad, hiding runaway slaves during the day and assisting them on their way to the Detroit River. Across the river was freedom in Canada. (Courtesy of the Wayne Historical Museum.)

On November 30, 1828, Pamela (née Pattison) Chubb married Glode Chubb. She bore him seven children. Her father, James Pattison, is also alleged to have been an agent on the Underground Railroad, hiding runaway slaves in his barn near what is now the southwest corner of Ford and Newburgh Roads. (Courtesy of the Wayne Historical Museum.)

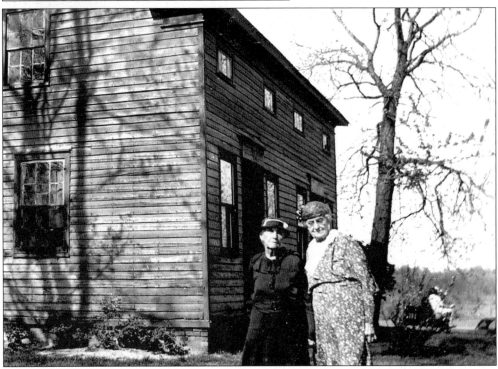

This was the Chubb home along Warren Road. The lady on the left is Olive (née Chubb) Barnard, the youngest of the seven Chubb children. (Courtesy of the Wayne Historical Museum.)

Betsey Cady was the wife of Samuel Pratt Cady. The Cadys owned 160 acres at the southwest corner of Wayne and Cherry Hill Roads. (Courtesy of the Wayne Historical Museum.)

Charles H. Cady was born on July 20, 1842. His mother died of tuberculosis just before his fourth birthday. Prior to the Civil War, Charles was a pitcher on a local baseball team. In his youth, he worked as a farmer and taught at both the Patchin and Cady Schools. He was also involved in village, township, and state politics. (Courtesy of the Wayne Historical Museum.)

On May 4, 1864, Charles H. Cady married Mary Jeanette Hodgkinson, the daughter of Bradshaw and Alice Hodgkinson. (Courtesy of the Wayne Historical Museum.)

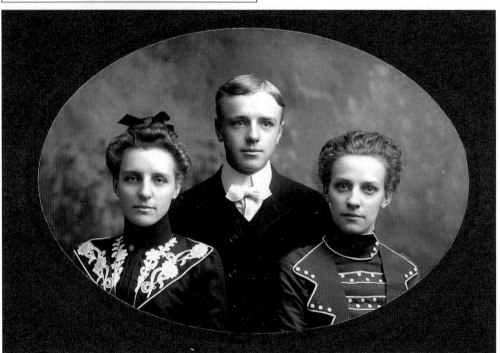

Charles H. and Mary Jeannette (née Hodgkinson) Cady had three children, Alice E. (born September 14, 1872), Samuel Bradshaw (born October 19, 1881), and Anna M. Cady (born on March 3, 1878). (Courtesy of the Wayne Historical Museum.)

Jesse Lorenzo Cady was the fifth son of Samuel Pratt and Betsey Cady. He became a homeopathic doctor. Homeopathy is a system of medicine in which a disease is treated by administering small doses of medicines that would produce the same symptoms in a healthy person. (Courtesy of the Wayne Historical Museum.)

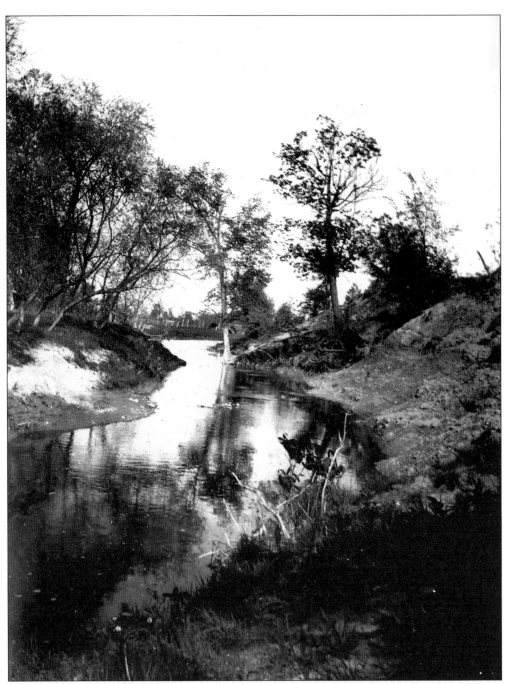

Two branches of the River Rouge flow through what was once Nankin Township. The land bordering the rivers was the best land for agriculture. These plots were among the first purchased from the federal government. In May of 1825, the Reverend Marcus Swift and his brother-in-law, Luther Reeves, traveled to Michigan. They followed the course of the Middle Rouge until they came to a point, " . . . about as near paradise as any locality they were likely to find. . . . " On May 10, 1825, they each purchased 160 acres of land in Nankin Township. (Courtesy of the Wayne Historical Museum.)

Reverend Marcus Swift moved to Nankin Township in October, 1825. He came with his wife, Anna, and four children, Osband (twelve), Hannah (ten), George (eight), and Orson (four). From 1827 to 1829, Marcus served as Township Supervisor of Bucklin Township. On June 11, 1828, Governor Lewis Cass appointed him a justice of the peace. In April of 1830, he became the first Township Supervisor of the newly formed township of Nankin. From 1825 through 1840, he was a tower of strength for the Methodist Episcopal Church, but withdrew from the Church in 1841 because he saw it as being in complicity with slavery. In 1843 Swift helped organize the Wesleyan Methodist Church. (Courtesy of the Bentley Historical Library, University of Michigan.)

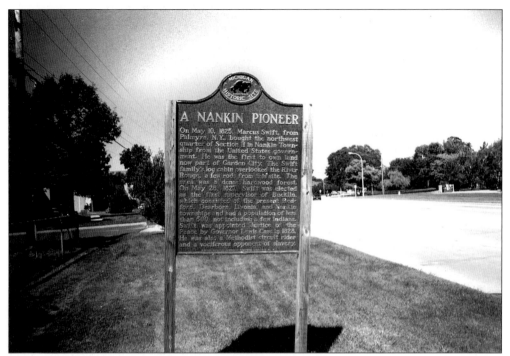

A state historical marker stands on the south side of Warren Road, at what was the middle of Reverend Marcus Swift's farm. His log cabin was north of the marker, overlooking the River Rouge. At first, Swift found it difficult to raise enough crops to feed his family. His wife, Anna, once exclaimed, "Marcus, we shall starve to death here." They did not starve to death, and after a couple of years the farm became a success. (Courtesy of Daryl A. Bailey.)

Marcus Swift's nephew, Melvin D. Osband, recorded, "Then commenced the work of turning the wilderness into a farm. Every acre was heavily timbered. Mr. Swift was without money, without tools, without a team, and with a limited stock of provisions. The farm had to be literally carved out by hand by himself and his two little boys—the oldest of whom, Osband, was but a lad of twelve years, and George was but eight." (Courtesy of the Wayne Historical Museum.)

On March 11, 1842, Marcus Swift's wife, Anna, died. Her nephew, Melvin D. Osband, recalled, "She had patiently shared with him the hardships of pioneer life sixteen years, struggling with poverty and privation till her physical strength became exhausted. She laid her burden down at the dawn of their temporal prosperity, in the meridian of life." (Courtesy of Daryl A. Bailey.)

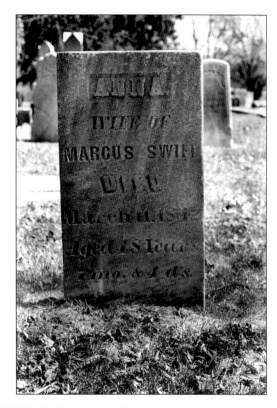

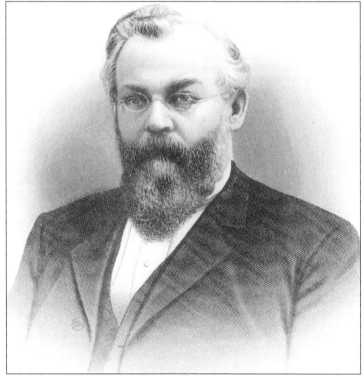

John Marcus Swift was the youngest son of Marcus Swift. He was born in Nankin Township on February 11, 1832. He became a doctor and moved to Northville. (Courtesy of the Wayne Historical Museum.)

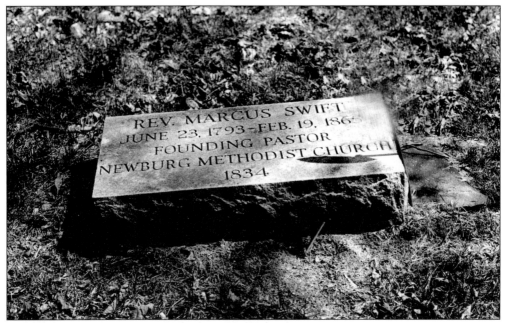

Marcus Swift died on February 19, 1865. His final resting place was the Newburgh Cemetery, located on Ann Arbor Trial between Wayne and Newburgh Roads. His last words were, "Now lettest thou thy servant depart in peace, according to thy word, for mine eyes have seen thy salvation." (Courtesy of Daryl A. Bailey.)

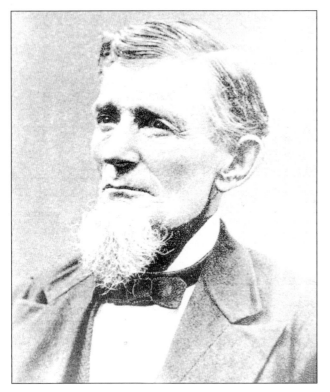

Andrew L. Chase married Elizabeth Swift, the sister of the Reverend Marcus Swift. He was the Overseer at Eloise from 1862 to 1866. (Courtesy of the Wayne Historical Museum.)

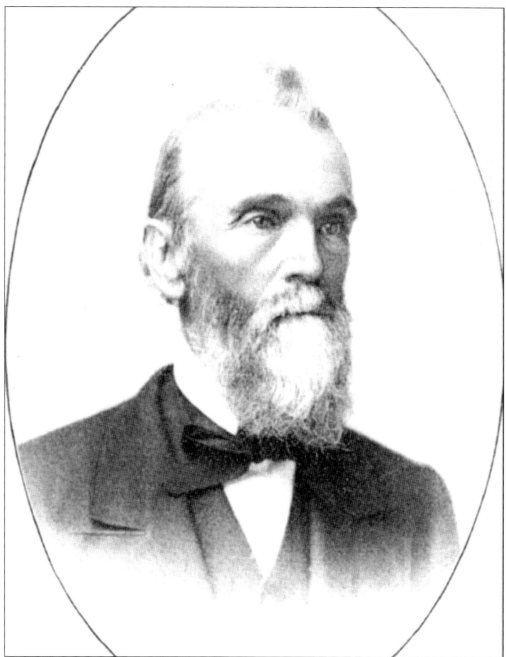

Melvin D. Osband was born in Palmyra, New York, on April 24, 1824. He was a year and a half old when he and his parents, William and Martha (nee Reeves) Osband, came to Nankin Township in October of 1825. He wrote about pioneer life in his account *My Recollections of Pioneers and Pioneer Life in Nankin*. In his text he paid tribute to his mother, "She had shared the toils and privations of pioneer life twenty-three years, had experienced all of its hardships with but little of its rewards. She had been a hard working woman from her childhood. She had borne and reared six sons on whom she had bestowed a mother's affection and a mother's care. The award of her children is, 'She did it well.'" (Courtesy of the Wayne Historical Museum.)

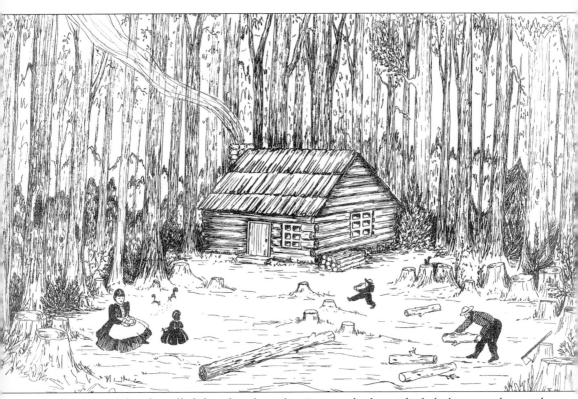

Melvin D. Osband recalled that their log cabin ". . . was built in a little hole cut in the woods just large enough to contain it. The work of cutting down the timber commenced immediately. In after years I heard my mother describe the terror she endured as the great trees came crashing down close to the house on all sides of it." (Courtesy of the Wayne Historical Museum.)

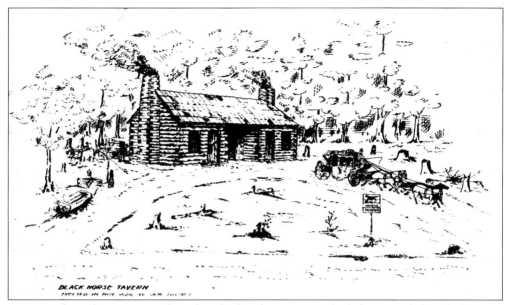

In November of 1829, Samuel Torbert built a log tavern, which he named the Black Horse Tavern. He ran the tavern for several years and it was a prosperous business. It was located on the north side of what is now Michigan Avenue, west of Henry Ruff. In 1839, the Black Horse Tavern became the Keeper's House for the new County House (later known as Eloise). (Courtesy of the Wayne Historical Museum.)

On November 1, 1831, Lawson Van Akins purchased 160 acres at what is now the southeast corner of Venoy and Warren Roads, in present-day Garden City. In 1846 he traded farms with Alanson Knickerbacker. The Knickerbacker farm was located along Ann Arbor Trail, about one-half mile east of Middlebelt Road. (Courtesy of the Wayne Historical Museum.)

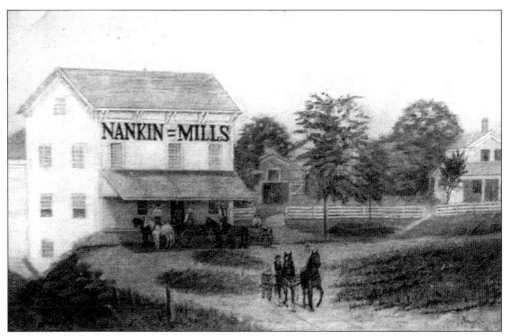

Two mills have occupied the site of Nankin Mills. Construction of the first mill began in 1835, but after a few weeks, work was stopped. Construction resumed in 1841 and the mill began turning grain into flour c. February, 1842. In 1863, a new mill building was constructed. It still stands along the south side of Ann Arbor Trail east of Farmington Road. (Courtesy of the Nankin Mills Interpretive Center Archives.)

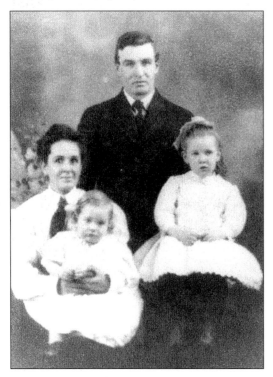

Floyd Bassett, pictured here with his family, was the last miller at Nankin Mills. In 1918, he sold the mill to Henry Ford. (Courtesy of the Nankin Mills Interpretive Center Archives.)

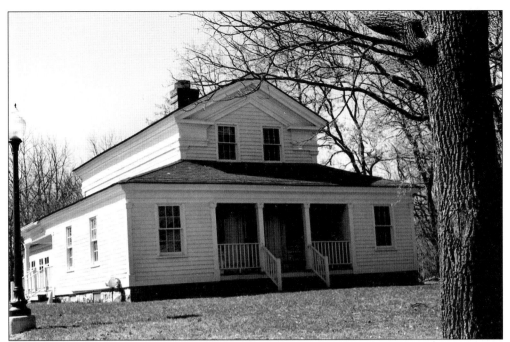

Constructed *c.* 1842, the Miller's House is located near Nankin Mills on Ann Arbor Trail. It is one of the oldest buildings still standing in the City of Westland. It served as the first Westland Historical Museum from 1974 to 1979. (Courtesy of Daryl A. Bailey.)

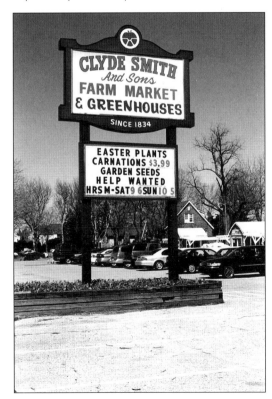

Clyde Smith and sons are a link to the community's farming roots. Their farmer's market and greenhouses are located on Newburgh Road. (Courtesy of Daryl A. Bailey.)

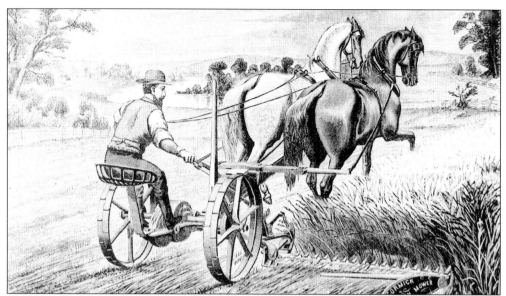

The first farmers in Nankin Township used primitive tools that had been around for centuries. It was hard, backbreaking work performed by the men and their sons. The 1830s saw the invention of many farm machines designed to make these tasks easier. Not until the Civil War, with the departure of most of the able-bodied males, was there a great demand for farm machinery, such as the mower pictured here. (Courtesy of the Wayne Historical Museum.)

Log cabins dotted the Nankin Township landscape during the pioneering era. (Courtesy of the Wayne Historical Museum.)

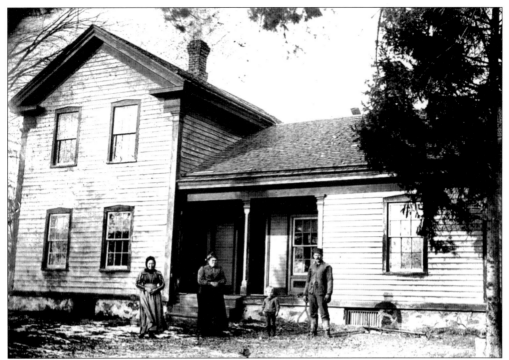

By the mid-1830s, sawmills were fully operational within the township. Recently constructed frame houses replaced log cabins. Pictured is a typical Michigan farmhouse constructed before the Civil War. It was located at the northeast corner of Cherry Hill and Middlebelt. (Courtesy of the Wayne Historical Museum.)

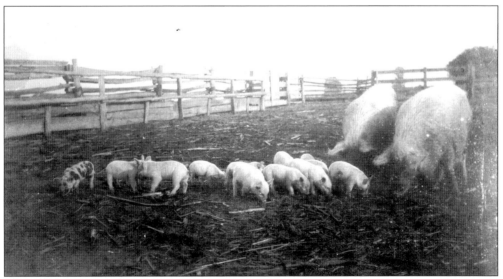

Hogs were among the first domesticated animals raised in Nankin Township. They could survive on acorns, which eliminated the need to buy feed. Butchering would occur in the fall of each year. Corn was one of the first grains grown, and "hogs and hominy" became part of the staple diet for early pioneers. In May of 1897, there were 271 hogs, six months or older, in Nankin Township. (Courtesy of the Wayne Historical Museum.)

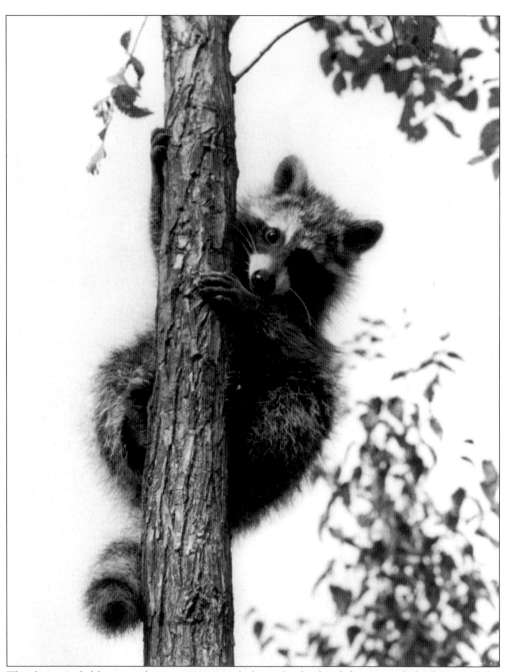

The farmer's field was under constant attack from the birds of the air and the beasts of the ground. The raccoons were as destructive during the night as the birds were during the day. One method of hunting raccoons was to assemble a group of men and boys. Armed with an ax and numerous torches, the group would spend half the night in the woods and cornfields searching for these "masked" bandits. Sometimes they had to cut down large trees to secure their prey. The farmer used raccoon fat as lamp oil. The raccoon pelts were worthless. William Osband selected 24 raccoon pelts to sell in Detroit, but the best offer he received was 25¢ for the lot. (Courtesy of the Michigan State Archives.)

44

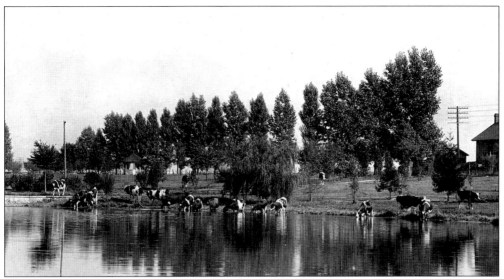

In May of 1897, there were 844 milch cows, six months or older, in Nankin Township. Milch cows are milking cows. There were also 217 additional heads of cattle in the township. (Courtesy of the Wayne Historical Museum.)

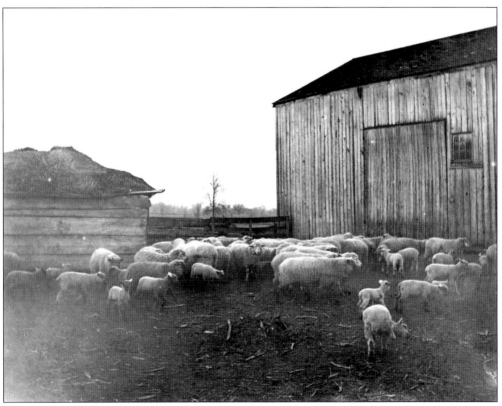

In May of 1897, there were 548 sheep, six months or older, in Nankin Township. The previous year, Nankin Township farmers sheared their sheep, yielding 2,952 pounds of wool. The farmers averaged 5.16 pounds of wool per sheep. (Courtesy of the Wayne Historical Museum.)

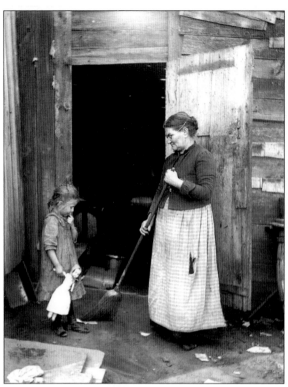

This was a typical Nankin Township farm scene. (Courtesy of the Wayne Historical Museum.)

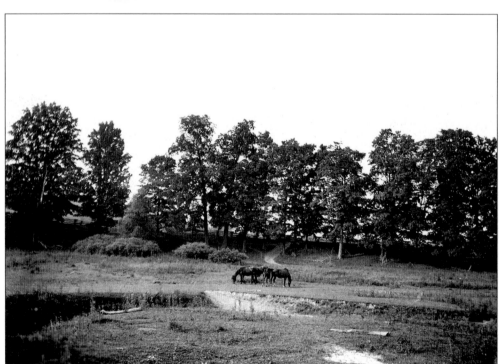

Pictured here are horses grazing on Fogerty Flats. In May, 1897, there were 584 horses, six months or older, in Nankin Township. (Courtesy of the Wayne Historical Museum.)

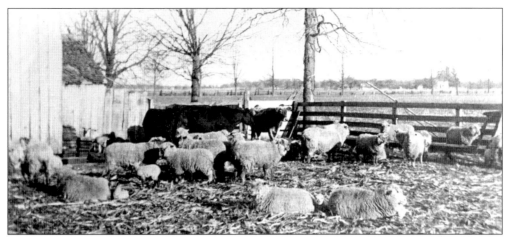

In 1897 some 71.76 percent of Nankin Township was farmland. Of that, 12,007 acres were improved, while 4,526 acres were unimproved. (Courtesy of the Wayne Historical Museum.)

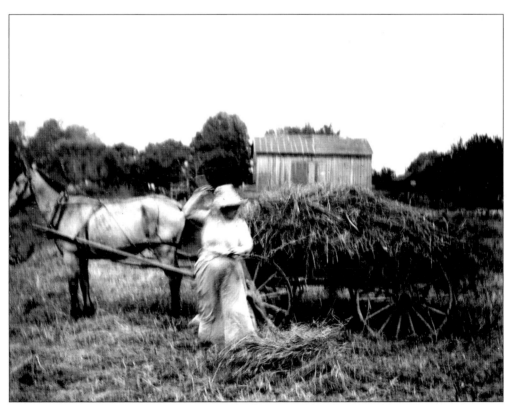

In 1896, farmers, such as this woman, in Nankin Township harvested 2,571 tons of hay. On average, each acre yielded 1.03 tons of hay. (Courtesy of the Wayne Historical Museum.)

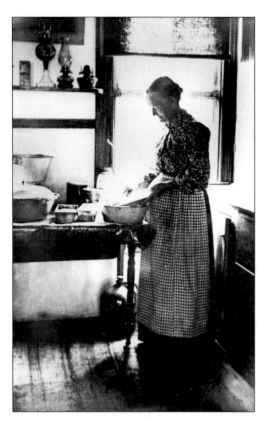

Here a woman uses wheat flour to make bread for her family. Wheat was an important crop in Nankin Township, covering 943 acres. In 1896, local farmers yielded 15.06 bushels of wheat per acre. (Courtesy of the Wayne Historical Museum.)

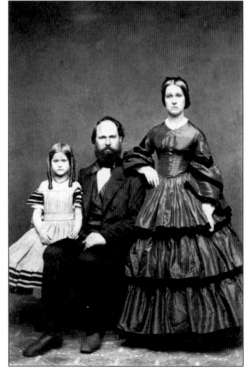

John J. Palmer, known as Jay, married his second wife, Mary E. Heywood, on September 22, 1849. On July 7, 1855, their first child, Ella Prudence Palmer, was born. (Courtesy of the Wayne Historical Museum.)

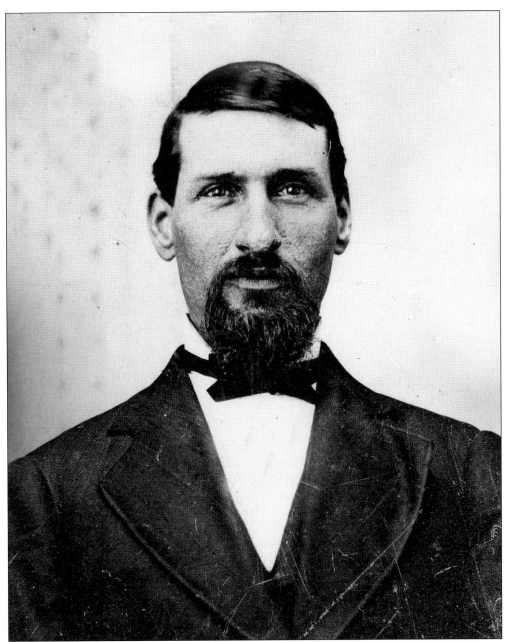

Zachary Merriman was born in Ecorse Township on March 4, 1849. The same day, President Zachary Taylor took his oath of office. The Merrimans choose the name Zachary as the perfect name for their baby boy. When Zachary Merriman was ten years old, he and his family moved to Nankin Township. Their farm was on what is now Merriman Road, west of Eloise. He remained on the family farm until his death on February 11, 1923. (Courtesy of the Wayne Historical Museum.)

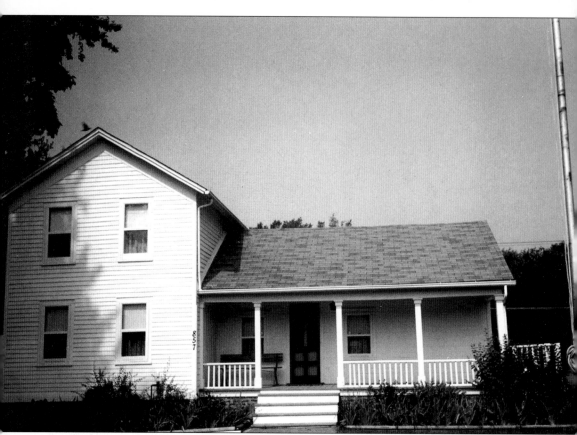

This is the Felton Farmhouse built *c.* 1860. On December 16, 1979, this farmhouse became the new home of the Westland Historical Museum. In the fall of 1998, the site became a classroom for a Wayne State archaeological field school, as Ph.D. candidate Jane Eva Baxter, from the University of Michigan, conducted the class. She used information obtained from these excavations in her Ph.D. dissertation. Jane is now an Associate Professor at DePaul University, Chicago, Illinois. This property, owned by the City of Westland, is now a state archaeological site, known as 20WN1052. (The number 20 indicates that the site is in Michigan, the 20th state to join the Union; the WN represents Wayne County, and it is the 1,052nd site so designated in the county.) (Courtesy of Daryl A. Bailey.)

Archaeological evidence indicates that the Feltons had cherry orchards. Jane Eva Baxter, Ph.D., recorded, "While it appears that the fruit trees that once comprised the economic basis of the farmstead were removed when the farm was dissolved, large quantities of cherry pits still remain." (Courtesy of the Wayne Historical Museum.)

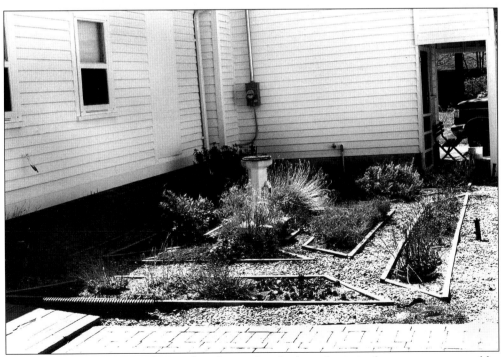

Archaeological evidence indicates that this modern herb garden is in the same spot as an older herb garden, perhaps that of Mrs. Felton. Evidence shows that the older herb garden was a little smaller than the present garden. (Courtesy of Daryl A. Bailey.)

The 1998 archaeological dig revealed butchered animal bones (both domesticated and wild) and wire fencing around this concrete platform. Jane Eva Baxter, Ph.D., recorded, "Butchering techniques were non-commercial, which suggests that animals were kept and slaughtered around the platform." (Courtesy of Daryl A. Bailey.)

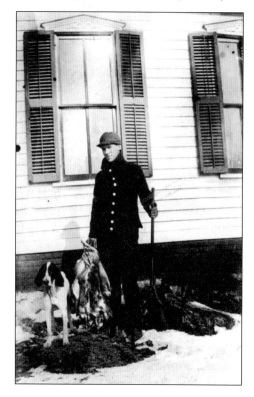

When early pioneers first arrived in Nankin Township, wild game was plentiful. Hunting was necessary for the pioneers' survival. As more people moved into the township, game became scarce. On August 5, 1958, township voters approved a ban on hunting within the township. The vote was 3,235 in favor and 1,421 opposed. (Courtesy of the Wayne Historical Museum.)

Three
EDUCATION

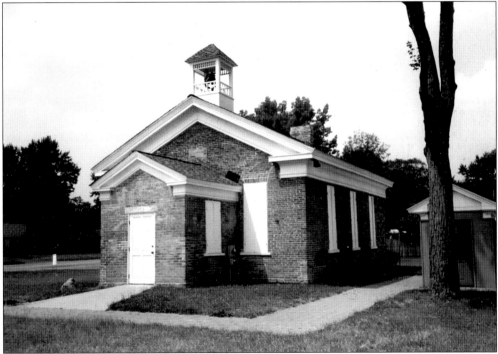

Constructed in 1856, the Perrinsville One-Room Schoolhouse, built on land owned by Isaac Perrin, was the first brick schoolhouse built in Nankin Township. Its dimensions are 26 feet wide and 36 feet long. This was the third schoolhouse to bear the name Perrinsville. Built in 1833, the first schoolhouse was located on land owned by the Reverend Marcus Swift. It stood at what is now the southeast corner of Warren and Merriman Roads. In 1843 construction of a new schoolhouse, on William Osband's farm, was completed. It stood on the north side of Cowan Road. The third schoolhouse was in operation from 1856 until 1937. (Courtesy of Daryl A. Bailey.)

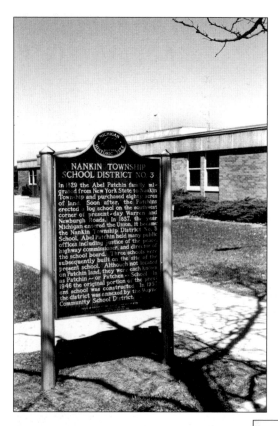

Abel Patchin arrived in Nankin Township in September of 1829. He purchased 80 acres across Newburgh Road from the present school that bears his name. While not very well educated, he believed in the value of an education. He built a log schoolhouse, on what is now the southwest corner of Warren and Newburgh Roads. In 1837, the school became Nankin Township School District No. 3. (Courtesy of Daryl A. Bailey.)

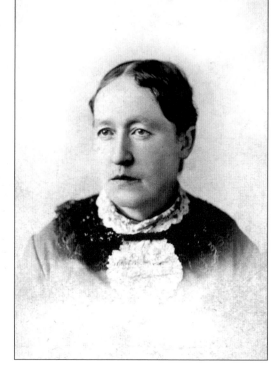

Harriet Patchin, the second daughter of Abel and Cornelia Patchin, was born three years after her parents arrived in Nankin Township. (Courtesy of the Wayne Historical Museum.)

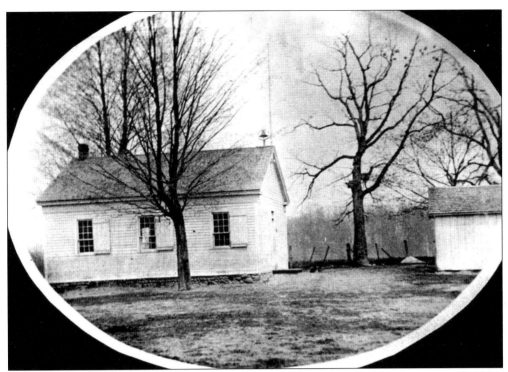

Built in 1840, this one-room, frame structure was the second Patchin School. It was the first school built on the present site of Patchin School. (Courtesy of the Wayne Historical Museum.)

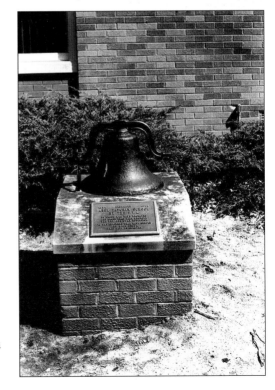

Constructed in 1921, the third Patchin School, a three-story brick building, replaced the schoolhouse built in 1840. This Patchin School bell was in operation from 1921 until 1964. The bell went into storage, where it remained until 1972 when it was returned to the school. (Courtesy of Daryl A. Bailey.)

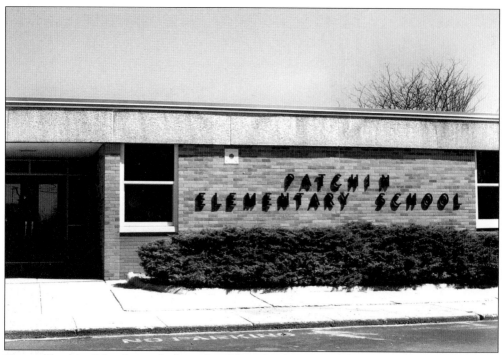

Here is Patchin School as it looks today. The school is part of the Wayne/Westland School District. (Courtesy of Daryl A. Bailey.)

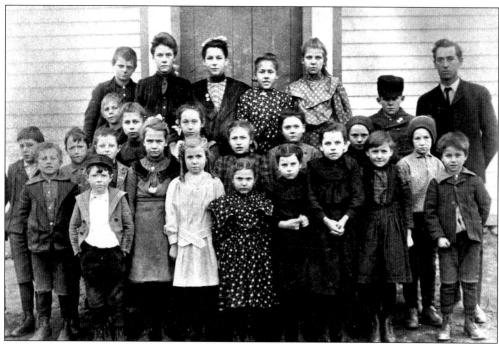

This is Cady School as it appeared c. 1905. It was located on the southwest corner of Wayne and Cherry Hill Roads. The intersection was known as Cady's Corner. (Courtesy of the Wayne Historical Museum.)

In 1922, a brick school was built on the northwest corner of Wayne and Cherry Hill Roads. It consisted of four classrooms, an assembly hall with a stage and dressing rooms, a kitchen, a school office, and a library. At this time there were no inside restrooms. In 1948, a second section of the school was built. An additional six rooms were added with federal funds in 1954. The Cady School was dismantled in late 1980. The Cady Center strip mall was built on the old school grounds. (Courtesy of Daryl A. Bailey.)

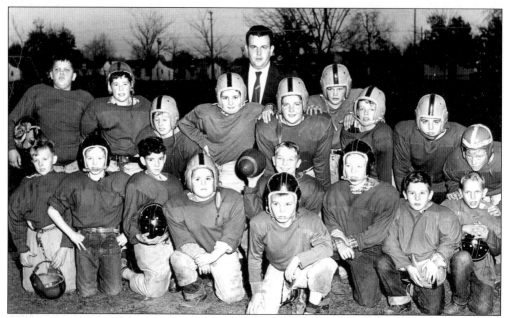

Pictured here is the Cady School football team, the year is not known. (Courtesy of the Wayne Historical Museum.)

Four Cady students prepare for bad weather. (Courtesy of the Wayne Historical Museum.)

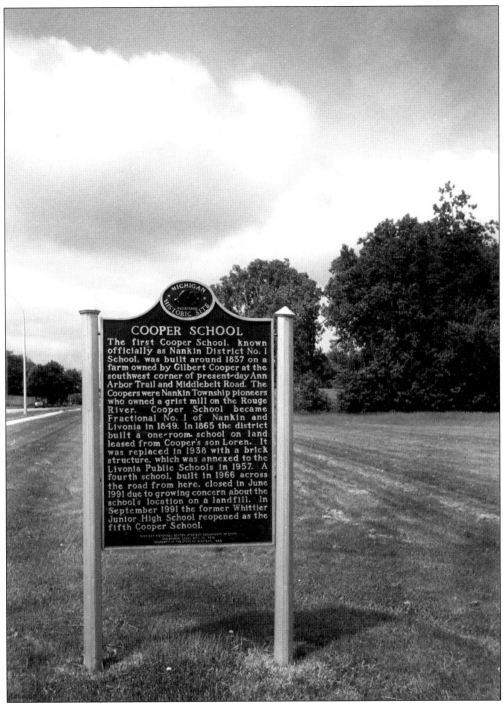

The first Cooper School, built *c.* 1837, became Nankin District No. 1 School. In 1849 it became Fractional No. 1 of Nankin and Livonia. In 1865, the second Cooper School was constructed. The third Cooper School, a three-room brick schoolhouse, was constructed in 1938. In 1957, the Cooper School was annexed by the Livonia Public School District. (Courtesy of Daryl A. Bailey.)

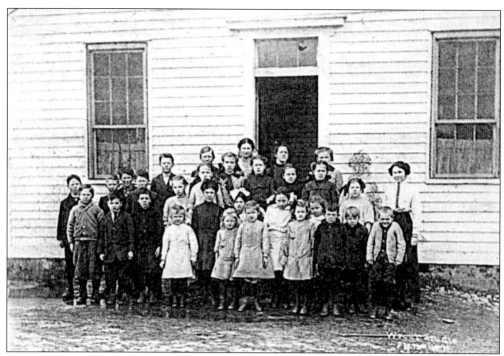

Pictured here is the Cooper One-Room Schoolhouse *c.* 1912. Constructed in 1865, this was the second Cooper School. (Courtesy of Edith Long, former Cooper Student, 1908–1914.)

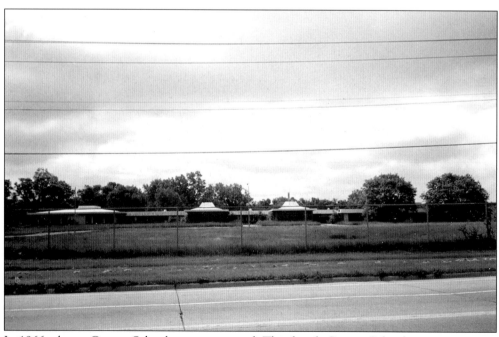

In 1966 a larger Cooper School was constructed. This fourth Cooper School was in operation until it closed in June, 1991 because it had been built on a contaminated landfill. (Courtesy of Daryl A. Bailey.)

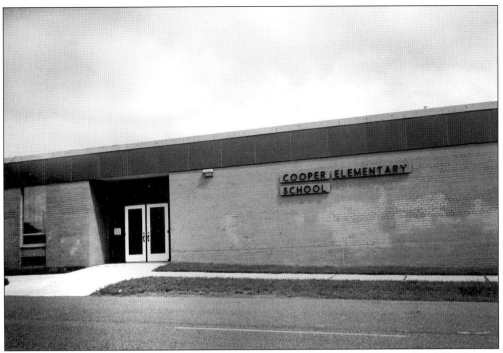

In September of 1991, the former Whittier Junior High School became the fifth Cooper School. (Courtesy of Daryl A. Bailey.)

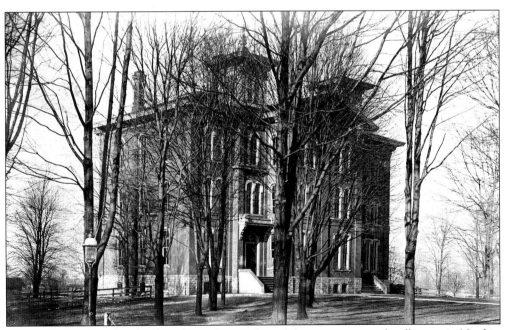

For many of the grade school students that graduated from one-room schoolhouses in Nankin Township, the only high school available to them was within the Village of Wayne. (Courtesy of the Wayne Historical Museum.)

This is Hazel Merriman at her graduation from high school. (Courtesy of the Wayne Historical Museum.)

Ada Merriman is pictured upon her graduation from high school. (Courtesy of the Wayne Historical Museum.)

Irene Ganong is pictured during her
freshman year at Wayne High School.
(Courtesy of the Wayne Historical Museum.)

This is Irene Ganong on her graduation day from
Wayne High School. (Courtesy of the Wayne
Historical Museum.)

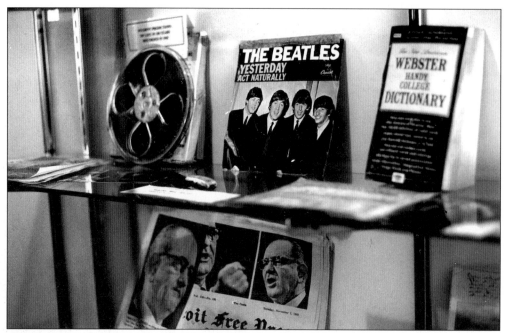

On November 2, 1965, students at Nankin Mills Junior High buried a time capsule. Many of the former students, as well as their teacher, were present on November 2, 2000, for the opening of that time capsule. Among its contents was a 45-RPM vinyl record. The A-side was a very fitting song for the time capsule—the Paul McCartney composition whose working title had been "Scrambled Eggs." It is better known as the Beatles' hit "Yesterday." (Courtesy of Daryl A. Bailey.)

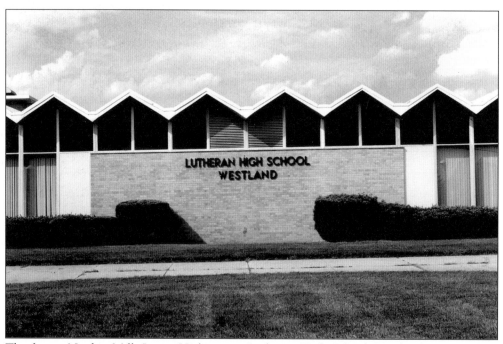

The former Nankin Mills Junior High is now Lutheran High School Westland. It opened on August 27, 1986. (Courtesy of Daryl A. Bailey.)

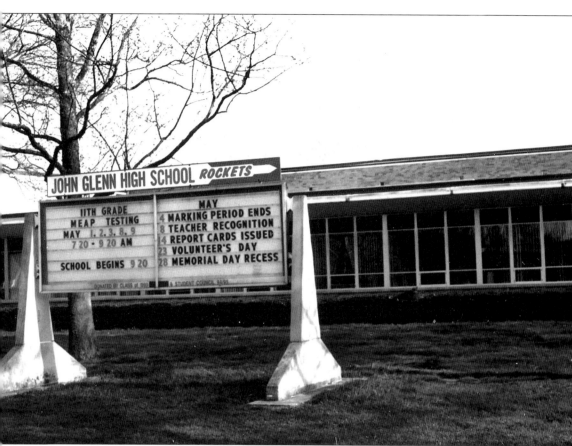

John Glenn High School is located on Marquette, west of Wayne Road. Groundbreaking for the high school, named in honor of astronaut John Glenn, occurred in the spring of 1963. The school was officially dedicated on November 8, 1964. On February 20, 1962, Glenn's Mercury 6 Mission was the first American manned orbital flight. Other names suggested for the high school were Nankin High School and Marquette High School. (Courtesy of Daryl A. Bailey.)

Opened in 1981, the William D. Ford Career-Technical Center has served the youths and adults in southeastern Michigan by preparing 15,000 highly skilled workers for jobs and careers. The center has state-of-the-art training equipment and machinery. Its mission statement reads, "We, the William D. Ford Career-Technical Center Staff will prepare our students with the knowledge, technological proficiency, and personal skills essential for success in an increasingly complex society." (Courtesy of the Westland Community Relations Department.)

Four

NANKIN DURING THE
CIVIL WAR

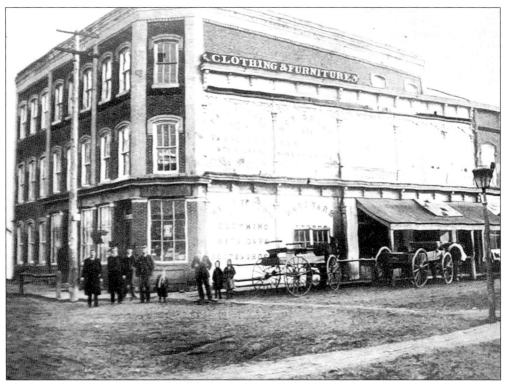

On Saturday, August 13, 1864, the *Detroit Advertiser and Tribune* reported that there was a meeting of the Order of American Knights (an anti-war group called Copperheads) on the third floor of O'Connor's Store. A year earlier, the *Detroit Free Press* reported that a group, called the Loyal League, was meeting in an abandoned house, one-half-mile south of Perrinsville. The Loyal League formed to counter any moves made by the Copperheads. (Courtesy of the Wayne Historical Museum.)

On August 12, 1862, University of Michigan student Orson B. Curtis enlisted in Company D, 24th Michigan Infantry. At the time of his enlistment, Orson was 21 years old. He lost his left arm during the Battle of Fredericksburg and Michigan newspapers erroneously reported that he died. He created quite a stir when he returned to the University of Michigan to complete his education. In 1891, he wrote a book on the history of the 24th Michigan Infantry. (Courtesy of Michigan Department of State Archives.)

Hiram Felton was born on March 3, 1844. On August 5, 1861, he enlisted in what became Company F, 16th Michigan Infantry. He received a gunshot wound in his right arm during the Second Battle of Bull Run, on August 30, 1862. The bullet splintered the bone, causing him to lose the use of his arm. On December 30, 1862, Hiram received his discharge from military service, due to his disability. Less than a year later, he was the best man in his older sister's wedding. (Courtesy of Michigan Department of State Archives.)

On October 28, 1863, Hiram's sister, Janetta Felton, married Ebenezer O. Bennett. In 1881, she became the Matron at the Wayne County House (Eloise). (Courtesy of the Wayne Historical Museum.)

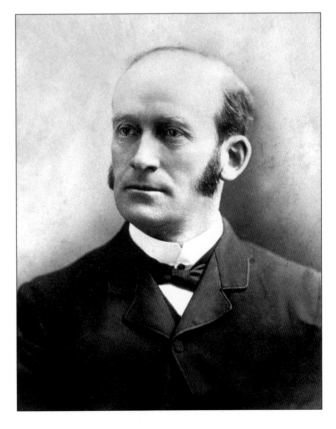

Five days before his wedding, Ebenezer O. Bennett enlisted in Company M, 1st Michigan Engineers and Mechanics Regiment. He reported for duty on November 9, 1863. He saw action at the Battle of Lookout Mountain, but spent the remainder of the Civil War on detached duty. On May 8, 1865, Bennett was honorably discharged from military service. In 1881, he became Medical Superintendent for the asylum portion of the Wayne County House (Eloise). (Courtesy of the Wayne Historical Museum.)

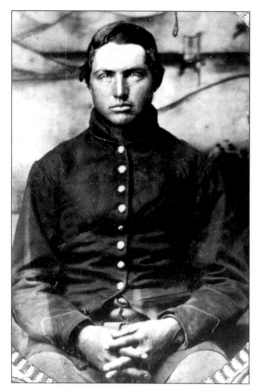

In 1861 "Brave Boys Are They" was a popular song. One of the verses said in part, "The time has come when brothers must fight, and sisters must pray at home." This was true for Lucius Chubb and his little sister, Olive. On July 31, 1862, Lucius enlisted in Company E, 24th Michigan Infantry. (Courtesy of the Wayne Historical Museum.)

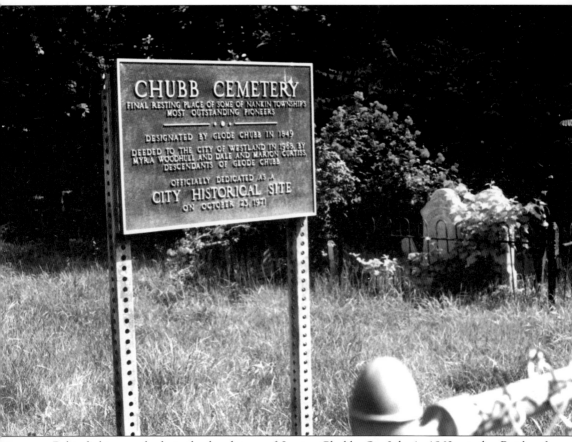

Behind this rose bush is the headstone of Lucius Chubb. On July 1, 1863, at the Battle of Gettysburg, Lucius received two buckshot wounds and fell into the hands of the Confederates. The Confederates left him behind when they retreated back to Virginia. Lucius was taken to a hospital in Philadelphia where, on August 17, 1863, he died of blood poisoning. The next day, his father, Glode Chubb, claimed his body and brought him back to Nankin Township. The Chubb Cemetery is located on the north side of Warren Road, west of Hix. (Courtesy of Daryl A. Bailey.)

On May 1, 1870, Henry Barnard, who served in the 9th Michigan Infantry, married Olive Chubb. The couple had three children. (Courtesy of the Wayne Historical Museum.)

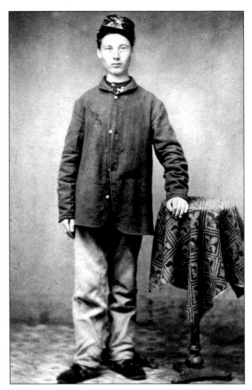

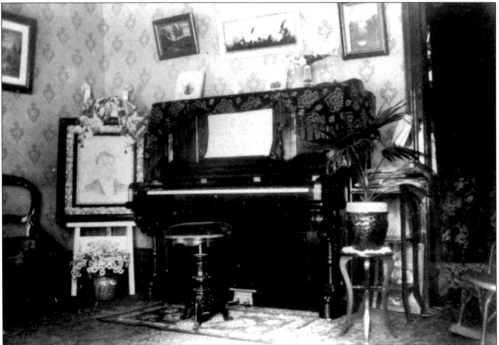

This is the parlor of Henry and Olive Barnard. The photograph on the table is of Lucius C. Barnard. He was born on June 28, 1874. He drowned at the age of 20. (Courtesy of the Wayne Historical Museum.)

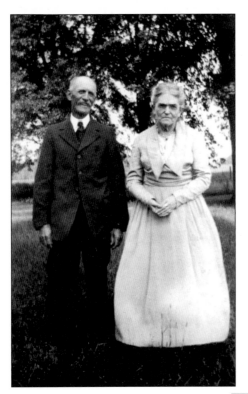

Pictured here are Samuel and Esther (nee Rounds) Bills. Esther was just six years old when her older brother, David Eugene Rounds, enlisted in Company D, 24th Michigan Infantry. Her brother was shot and killed on the first day of the Battle of Gettysburg, July 1, 1863. (Courtesy of the Wayne Historical Museum.)

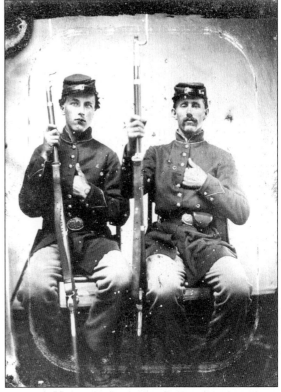

Pictured here are two unidentified Civil War soldiers. Men from Nankin Township served in many Union units. Among them are the 16th Michigan Infantry, the U.S. Sharpshooters, the 1st Michigan Engineers and Mechanics, the 4th Michigan Cavalry, 8th Michigan Cavalry, and Battery E, 1st Michigan Light Artillery. (Courtesy of the Wayne Historical Museum.)

Ezra E. Derby, the son of Wayne's founder, Ezra Derby, enlisted in the 24th Michigan Infantry. He spent most of this service on detached duty, as an extra caisson driver in Battery B, 4th U.S. Artillery. On June 23, 1864, he died of wounds he received five days earlier during the siege of Petersburg, Virginia. (Courtesy of the Wayne Historical Museum.)

On July 4, 1860, Ezra E. Derby married Maria Monroe. This union produced no children. She remarried twice and died on April 27, 1923. (Courtesy of the Wayne Historical Museum.)

Harriet, Ezra E. Derby's sister, married Otis Southworth. During the course of the Civil War she would lose both her husband and her brother. (Courtesy of the Wayne Historical Museum.)

On August 9, 1862, Otis Southworth enlisted in Company C, 24th Michigan Infantry. The regiment was engaged in heavy fighting during the first day of the Battle of Gettysburg, July 1, 1863. Otis was shot in the head, died instantly, and was buried near the spot where he fell. His body was later moved to the Gettysburg National Cemetery, where he rests, in Michigan Plot, Section A, grave 10. (Courtesy of the Wayne Historical Museum.)

Here are examples of women's fashion during the Civil War. (Courtesy of the Wayne Historical Museum.)

On August 6, 1862, Abel G. Peck enlisted in Company C, 24th Michigan Infantry. Eight days later he broke the news of his enlistment to his daughter, Alice, in a letter. He said, "With a heart beating high with emotion . . . I have enrolled myself as a volunteer for our Country and its flag. Painful as it is I feel it to be my duty." Abel became the flag bearer of the regiment. He was the first in the regiment to fall at the Battle of Gettysburg, July 1, 1863. On the eve of an earlier battle, he wrote the following lines to Alice, ". . . You must not mourn for I think I am doing my duty and you must think that the honor of having a father die in the defense of his country will make up for the loss you will sustain" (Courtesy of the Michigan Department of State Archives.)

The Reverend William C. Way was the chaplain of the 24th Michigan Infantry. He was the only chaplain of a Michigan regiment to serve with his regiment for its duration of federal service. (Courtesy of the Wayne Historical Museum.)

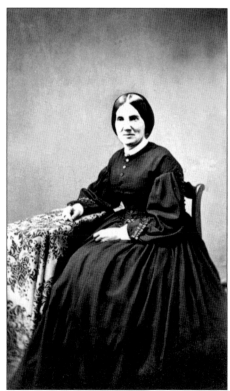

On August 30, 1845, Reverend William C. Way married Eliza M. Lane, in Moscow, New York. They would later move to Michigan. (Courtesy of the Wayne Historical Museum.)

Private Henry M. Winsor, of Nankin Township, appeared on the list of officers and men of the 4th Michigan Cavalry who took part in the expedition that captured Confederate President Jefferson Davis. There was a $100,000 reward for the Confederate President's capture. A military commission concluded that the men of the 4th Michigan Cavalry were entitled to receive the reward. Members of the 1st Wisconsin Cavalry also claimed the reward. Congress decided that each member of the two regiments who participated in the expedition would receive an equal share of that reward. (Courtesy of the Michigan Department of State Archives.)

From left to right are Henry Loss, Emma John, and Ida Collar. On Thanksgiving Day 1864, Henry Loss, a member of the 24th Michigan Infantry, took ill with diarrhea after eating some potatoes. In February 1865, the native German ate potatoes and took ill again. (Courtesy of the Wayne Historical Museum.)

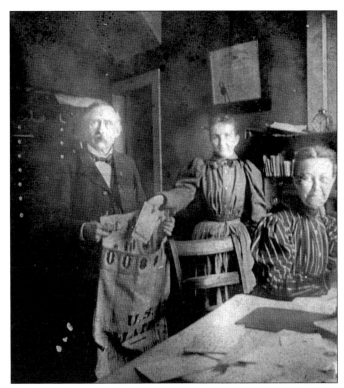

On August 13, 1862, Joel R. Brace enlisted as a private in Company F, 24th Michigan Infantry. This was a time when the army needed as many men as they could in the field. On November 13, 1862, he was discharged, due to disability. The military surgeon stated that he, ". . . ought not to have been enlisted." (Courtesy of the Wayne Historical Museum.)

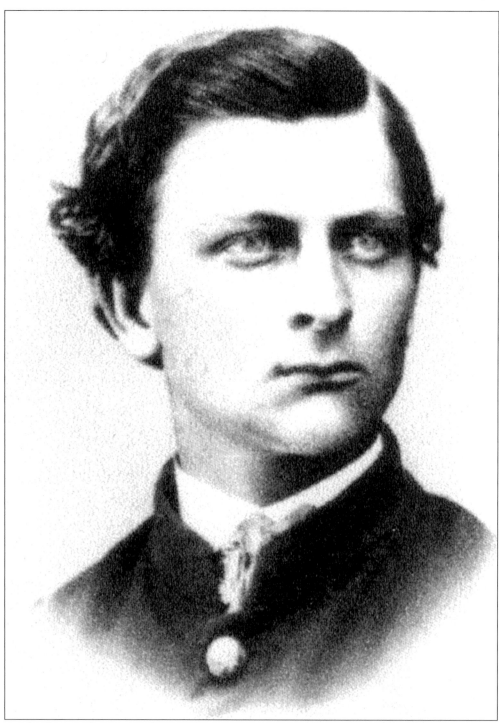

Ira Fletcher was born in Taylor, Michigan. On July 31, 1862, he enlisted in Company K, 24th Michigan. He was missing in action and captured by Confederate forces at Gettysburg. In September of 1863, the Confederates paroled him. (Courtesy of the Michigan Department of State Archives.)

Pictured here is Dr. Ira Fletcher. After serving in the Civil War, he went to medical school and became a doctor. On May 9, 1883, he died of pneumonia. (Courtesy of the Wayne Historical Museum.)

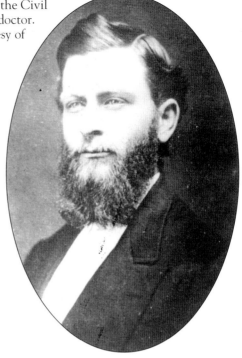

On May 15, 1877, Ira Fletcher married 26-year-old Mary Lizette Collins. She died on April 22, 1914. (Courtesy of the Wayne Historical Museum.)

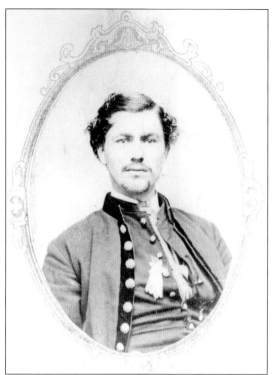

On August 13, 1862, Almon J. Houston and his brother William H. enlisted in Company D, 24th Michigan Infantry regiment. The regiment was known as the "family regiment." Within its ranks were 135 pairs of brothers. Almon was wounded and captured by Confederate troops during the first day's fighting at Gettysburg, on July 1, 1863. He eventually found himself confined at Andersonville Prison and lived to tell the tale. (Courtesy of the Wayne Historical Museum.)

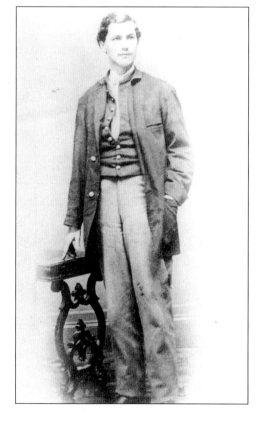

On August 13, 1862, William H. Houston enlisted in Company D, 24th Michigan Infantry. He was only 20 years old when a Confederate bullet struck him in the head, killing him instantly. He was one of many in the 24th Michigan to die on July 1, 1863, on the bloody battlefield at Gettysburg. (Courtesy of the Wayne Historical Museum.)

Five

TRANSPORTATION

The Sauk Trail was a series of Native American footpaths. As settlers moved into southeast Lower Michigan, the trail developed into the Chicago Military Road. Today we know this as Michigan Avenue. (Courtesy of the Wayne Historical Museum.)

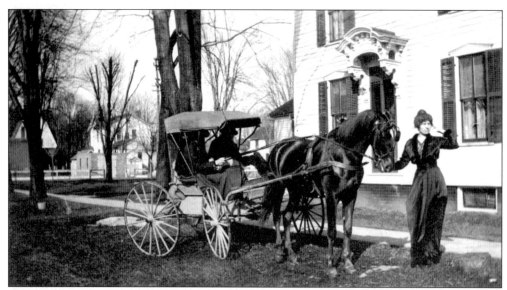

Before the advent of the automobile, the horse and buggy was "the king of the road." (Courtesy of the Wayne Historical Museum.)

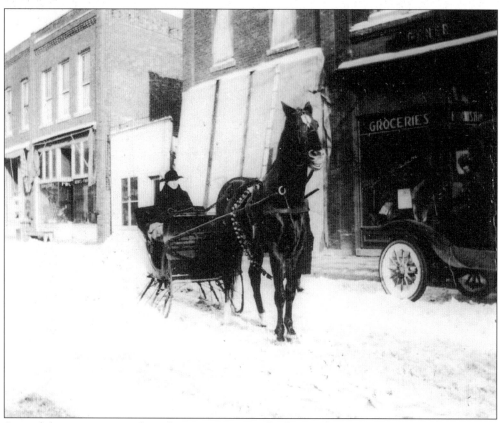

Snow did not prevent residents from getting around. The one-horse open sleigh could get them to grandma's house. (Courtesy of the Wayne Historical Museum.)

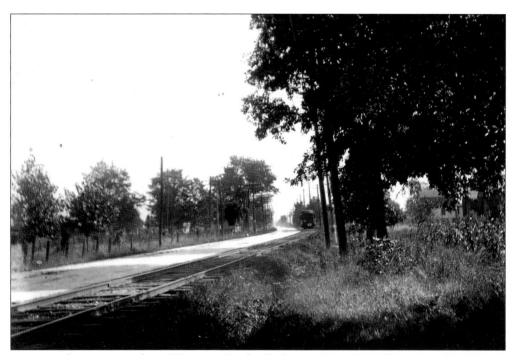

An Interurban route ran from Wayne to Northville from 1899 to 1926. (Courtesy of the Wayne Historical Museum.)

This is a ticket for the Interurban. Note the Nankin Township stops, under the Plymouth Division, which are now part of the City of Westland. These include Palmer Road, Tombs, Robinson Road (now known as Cherry Hill Road), Newcomb Road, and King Road (now known as Warren Road). (Courtesy of Richard Andrews.)

VALUE OF TICKET OR CASH FARE COLLECTED PUNCH STAR		
12c ★		
14c ★		
18c ★		
22c ★		
24c ★		
28c ★		
29c ★		
31c ★		
34c ★		
54c ★		
61c ★		
74c ★		
98c ★		
1.28 ★		
1.38 ★		
1.57 ★		
1.69 ★		
1.84 ★		

DOLLARS 2 1
DIMES
CENTS 1 2 3 4 5 6 7 8 9
DIMES 1 2 3 4 5 6 7 8 9

DETROIT	Staebler
Addison	Dexter
P. M. Crossing	Parker
Schaffer	Steinbach
Town Line Road	Dancers
Recknor	Lima Ctr.
Duffield	Fletcher
DEARBORN	Freer
St. Joseph's Retreat	Town Line
Telegraph	CHELSEA
Gulley	Haeffner
Westwood	W. Guthrie
Inkster	Sylvan
Henry Ruff	Hoppe
Eloise	Nutten
Merriman	FRANCISCO
WAYNE	Bachman
Hannan	Gruener
Artley	Schoening
Lilley	GRASS LAKE
Sheldon	Updike
Belleville	Leoni
Beck-	Murray
Denton	Ballard
County Line	Mich. Ctr.
Ridge	Sutton
Wiard	Dettman
Harris	Page
YPSILANTI	JACKSON
Hewett-	PLYMOUTH DIVISION
Cook	Wayne
Carpenter	Palmer Rd.
Platt	Tombs
Stone Schl.	Robinson Road
ANN ARBOR	Newcomb Road
Ann Arbor & Scio T. L.	King Rd.
Wagner	Livonia Town Line
Delhi	Newburg
Zieb	Plymouth Town Line
TICKET	Plymouth Village
HALF	Purdy Rd.
COM.	Waterford
CARD	Northville Vil. Limits
TRIP	Northville Village

DETROIT, JACKSON & CHICAGO RAILWAY

NOTICE TO PASSENGERS. RETAIN THIS RECEIPT AS EVIDENCE OF FARE PAID BETWEEN STATIONS PUNCHED.

WEST ... BOUND

JAN. FEB. MAR. APR. MAY JUNE JULY AUG. SEP. OCT. NOV. DEC.

1 2 3 4 5 6 7 8 9 10 11 12 13 14 15 16 17 18 19 20 21 22 23 24 25 26 27 28 29 30 31

NO. 6763 FORM D J W

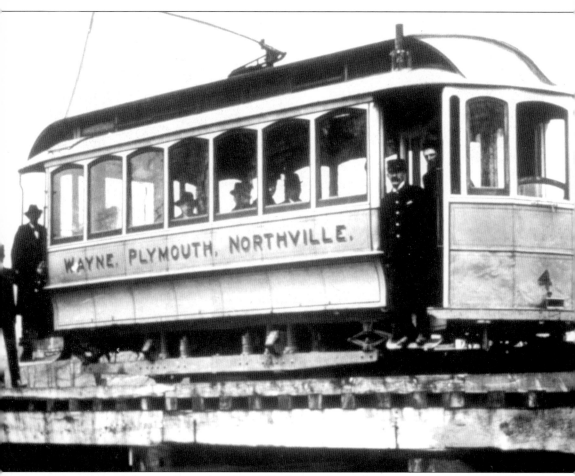

It was reported that on December 26, 1909, that an Interurban car, traveling on the Wayne, Plymouth, Northville Line, jumped the track at Cady's Corner, four miles north of Wayne. The car skidded about 50 feet through the snow, ran into a pole, and flipped on its side. In the wild scramble that followed, the less seriously injured made their way out of the car and then turned to assist those pinned down in the wreckage. While many passengers were injured, only one died at the scene, however others would later die at the hospital. (Courtesy of Richard Andrews.)

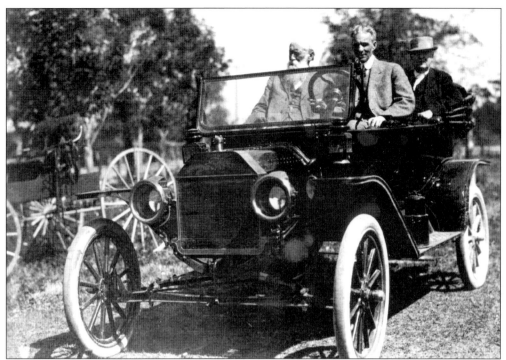

In 1908 the world changed with the introduction of Henry Ford's Model T. Nicknamed the "Tin Lizzie," the Model T was a practical automobile, without many frills and extras. It was easy to operate, durable, reliable, and priced to be affordable to the masses. Pictured in the front seat are naturalist John Burroughs (left), Henry Ford (right), and inventor Thomas Edison (in the back seat). (Courtesy of Ford Motor Company.)

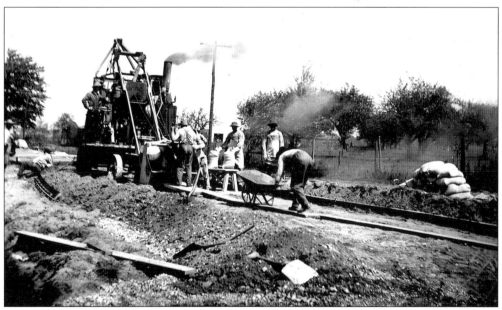

The first paving of Michigan Avenue took place in 1913. (Courtesy of the Wayne Historical Museum.)

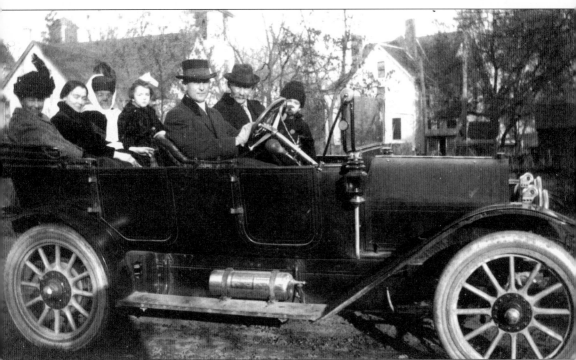

Seated behind the steering wheel is Peter J. Snyder. He was Nankin Township Supervisor in 1933 when President Franklin D. Roosevelt started the Civilian Conservation Corps (CCC). In 1933, Nankin's quota of volunteers was 65, much higher than any other township in Wayne County. Able-bodied men between the ages of 18 to 25 could apply for the program. Supervisor Snyder selected the 65 based on who were the best qualified and deserving. Those selected were paid $30 a month, with $25 of it sent as an allotment to the young man's family. (Courtesy of the Wayne Historical Museum.)

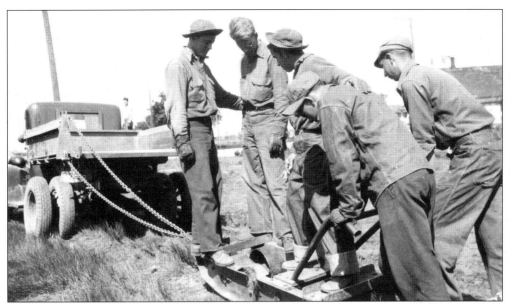

Men from CCC Company 1618 break up sod along Michigan Avenue. During the 1930s a new Michigan Avenue was constructed. There were just enough funds for the road and rough ditches. Company 1618 was to grade, seed, and landscape the shoulders and boulevard. They worked on a 16-mile stretch of Michigan Avenue from Holmes Road, in eastern Washtenaw County, to Telegraph Road, in Western Wayne County. (Courtesy of William Branton.)

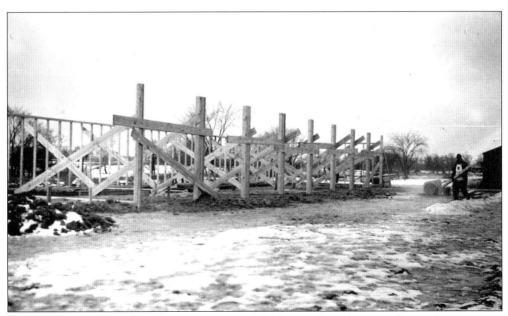

A camp was constructed to house Company 1618. A site selected was on the southwest corner of Hix and Glenwood Roads; it was part of Irving Carpenter's farm. Construction began October 8, 1935. The camp was ready November 2, 1935. (Courtesy of William Branton.)

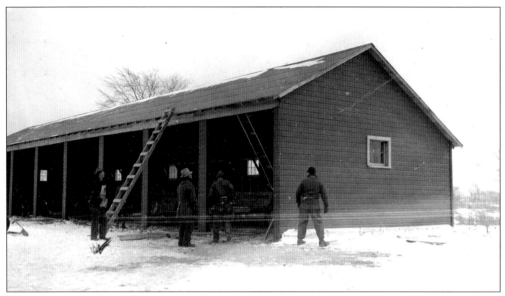

The camp was called SP13, meaning State Park number 13, or Camp Wayne. The camp closed in the summer of 1938. (Courtesy of William Branton.)

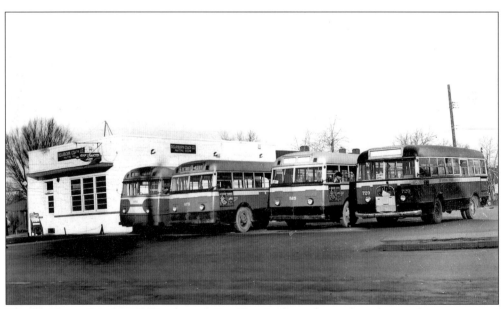

The Dearborn Coach and Greyhound Bus Terminal was located at the northeast corner of Michigan Avenue and Laura. The Greyhound Bus Terminal is now located on Wayne Road. (Courtesy of the Wayne Historical Museum.)

Six
THAT'S ENTERTAINMENT

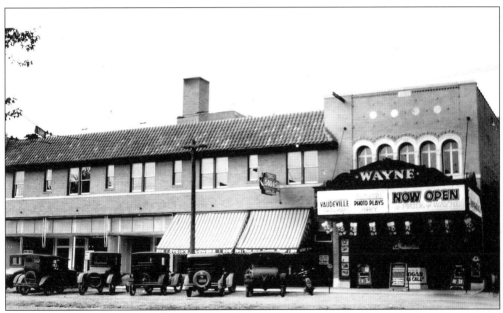

August 27, 1927, was opening night at Wayne Theatre. The doors opened at 6:30 p.m. A standing-room-only audience saw *Tillie the Toiler*, a comedy starring Marion Davies, Matt Moore, and George Fawcett. Also on the bill that night was an "Our Gang" comedy entitled *Yale vs. Harvard*, the first of the "Our Gang" comedies released by MGM. Additionally, the audience saw a Paramount News short and five vaudeville acts. The theatre was a smashing success. People from all over Nankin Township and the surrounding area flocked to the theatre. (Courtesy of Wayne Historical Museum.)

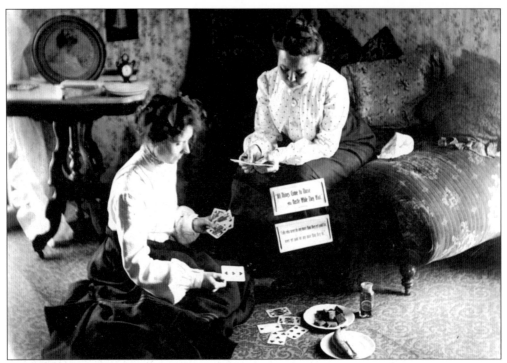

Ida Collar and a friend play cards at a Spinster's Club meeting, *c.* 1916. Ida, who never married, was the daughter of local physician Alexander Collar. (Courtesy of the Wayne Historical Museum.)

Before the age of CDs and boom boxes, area residents enjoyed listening to wax recordings played on this early phonograph. (Courtesy of the Wayne Historical Museum.)

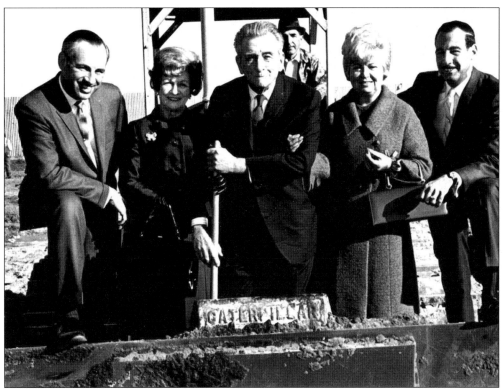

In 1966, ground was broken for the Qua Vadis Movie Theater, on Wayne Road across from the Westland Mall. Pictured here from left to right are Charles Shafer, Mrs. Lillian Shafer, actor Edward Everett Horton, an unidentified woman, and Martin Shafer. (Courtesy of the Wayne Historical Museum.)

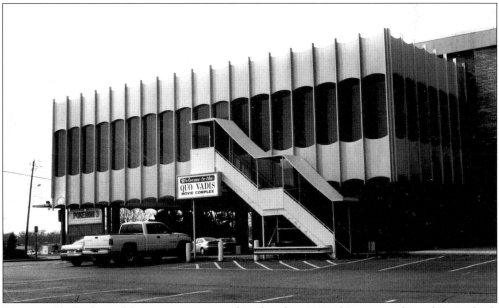

The Qua Vadis showed first run movies until it closed in 2002. (Courtesy of Daryl A. Bailey.)

Pictured here from left to right are Charles and Martin Shafer. (Courtesy of the Wayne Historical Museum.)

Swimming in the River Rouge was once a refreshing and inexpensive means of entertainment. (Courtesy of the Wayne Historical Museum.)

Prior to global warming and industrial waste, area residents would ice skate on the frozen surface of the Rouge River. (Courtesy of the Wayne Historical Museum.)

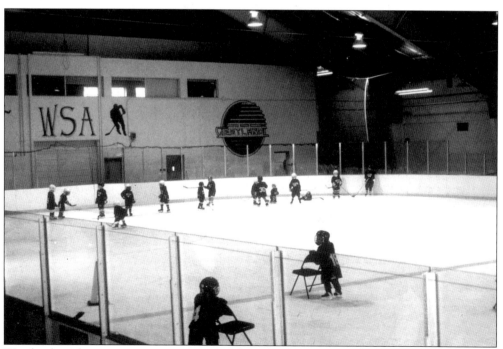

Westland residents can participate in or watch ice hockey. In 2003 the Westland Sports Arena was renamed the Mike Modano Ice Arena, after this professional hockey player. (Courtesy of the Westland Community Relations Department.)

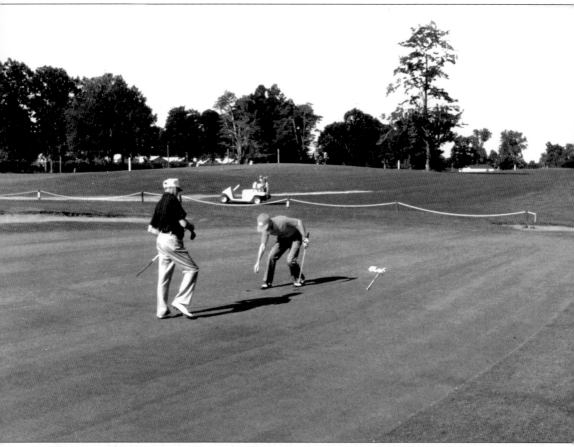

The nine-hole Westland Municipal Golf Course was once part of the 18-hole Birch Hill County Club, which had been at the corner of Cherry Hill and Merriman. The Municipal Service Bureau, a non-profit organization established in 1977, manages the municipal course. A private developer purchased a portion of the original 105-acre golf course. Among the commercial businesses at the corner of Cherry Hill and Merriman is a Farmer Jack grocery store. (Courtesy of the Westland Community Relations Department.)

Seven
ONE OF HENRY'S HOBBIES

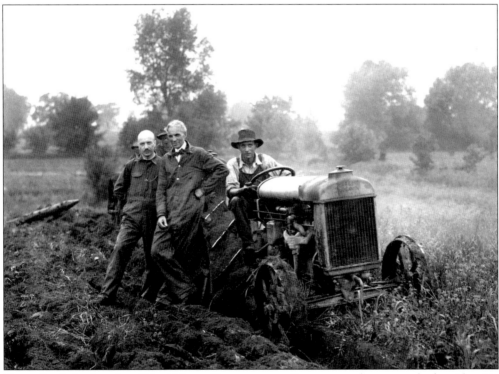

Henry Ford, the founder of Ford Motor Company, standing next to the tractor, had an idea. He would dot America's rivers with water-driven factories that would offer employment to farmers during the winter months—thus slowing the migration of families from the farms to the cities. Referred to as "village industries" or "Henry's Hobbies," many of these factories were restored 19th century gristmills. (Courtesy of Ford Motor Company.)

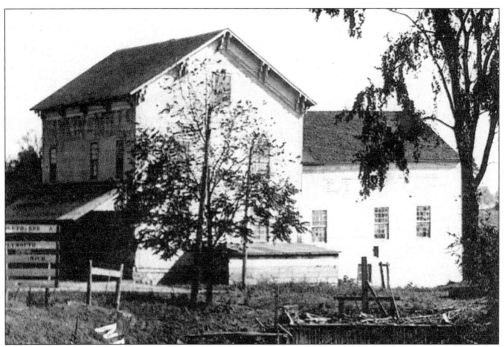

In 1918 Henry Ford purchased Nankin Mills from Floyd Bassett. According to one of Bassett's daughters, her father was unaware of the identity of the purchaser until the final closing. (Courtesy of the Nankin Mills Interpretive Center Archives.)

Fred Voss and family lived on a farm located across from Nankin Mills. (Courtesy of the Nankin Mills Interpretive Center Archives.)

Fred Voss epitomized Henry Ford's belief in keeping "one foot in the factory and one foot on the ground of nature." Voss lived and worked on his farm, while also working in the Nankin Mills "powerhouse," keeping the turbine in operating order. (Courtesy of the Nankin Mills Interpretive Center Archives.)

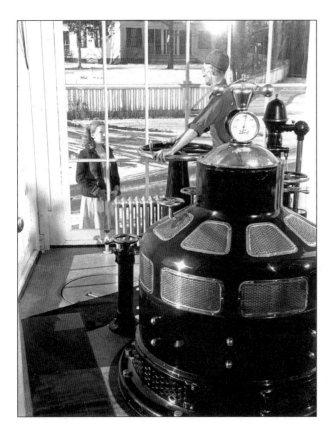

This is the generator room constructed in late 1920s, replacing a simple clapboard room. This room is typical of the generator rooms in other Ford village industries. Here Fred Voss' daughter watches her father work. (Courtesy of the Nankin Mills Interpretive Center Archives.)

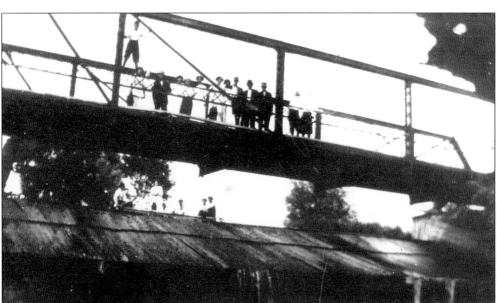

Between 1919 and 1944, Henry Ford opened 20 village industries. They allowed Ford to fulfill two of his heartfelt beliefs, to support rural farming and to use waterpower. Pictured here is dam renovation work on the River Rouge. (Courtesy of the Nankin Mills Interpretive Center Archives.)

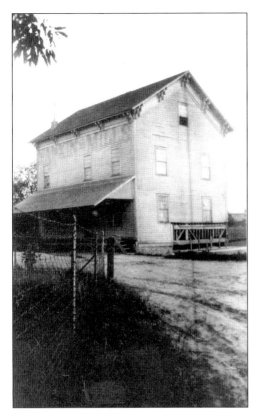 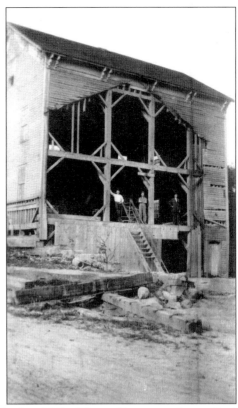

Between 1918 and 1920, Henry Ford restored Nankin Mills. The mill re-opened as a Ford factory in 1920. (Courtesy of the Nankin Mills Interpretive Center Archives.)

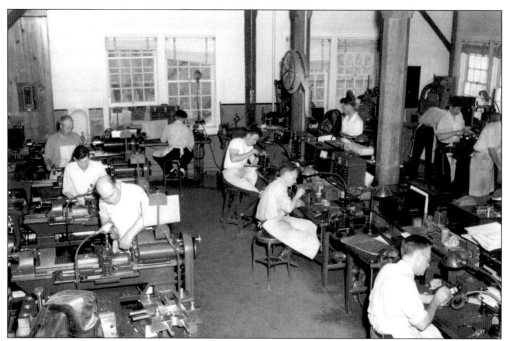

Lathe operators and tool makers turning out Ford parts. (Courtesy of the Nankin Mills Interpretive Center Archives.)

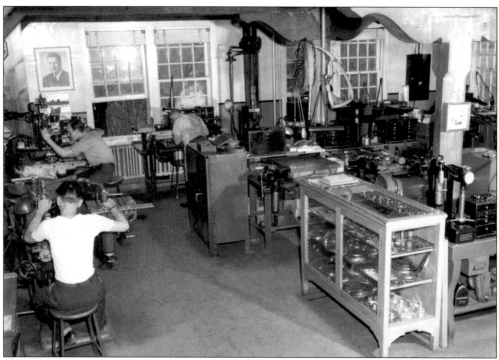

The display case to the right contains automotive parts produced at Nankin Mills. In 1922 the mill was turning out drive shaft bearings, carburetor parts, and engravings. (Courtesy of the Nankin Mills Interpretive Center Archives.)

In 1935, Nankin Mills took over the responsibility of designing identification badges for Ford Motor Company. The badge pictured, used from 1937 to 1966, is that of an employee at the Rouge Plant. The star indicates that the employee was a supervisor. (Courtesy of the Collection of Tim O'Callaghan.)

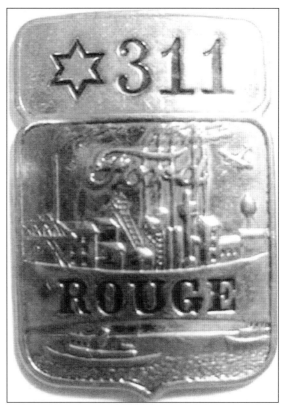

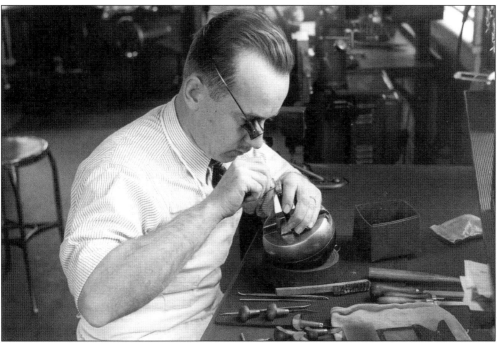

Nankin Mills produced stencils for marking Ford parts. (Courtesy of the Nankin Mills Interpretive Center Archives.)

These are front and side views of a pantograph used at Nankin Mills. The pantograph would trace the contours of a pattern, translating them to the milling machine, which would then cut the mold. (Courtesy of the Nankin Mills Interpretive Center Archives.)

Pictured here is one of the many unsung Ford employees who made Nankin Mills a success for many years. (Courtesy of the Nankin Mills Interpretive Center Archives.)

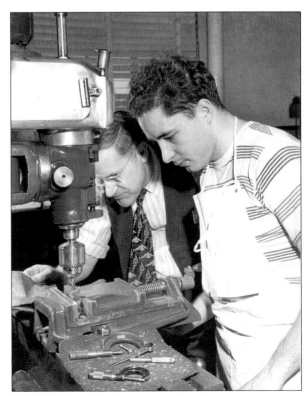

Nick Nichols, a foreman at Nankin Mills, is seen here working with a young apprentice. (Courtesy of the Nankin Mills Interpretive Center Archives.)

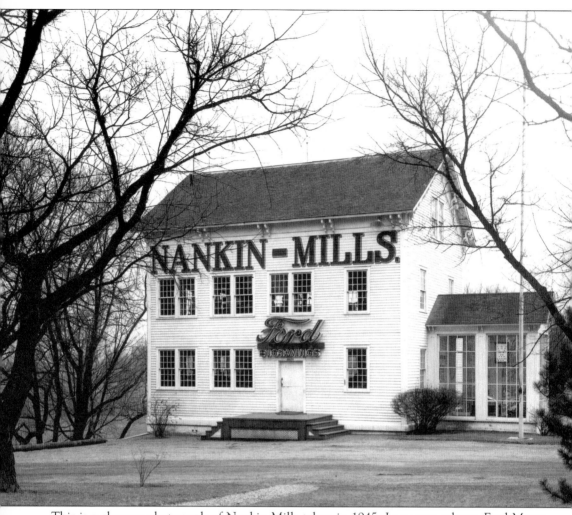

This is a close-up photograph of Nankin Mills taken in 1945. In a press release, Ford Motor Company stated that, "There were several (village industries) whose [sic] output was frankly of no commercial value and whose existence traced only to Mr. Ford's commonly known characteristic of extending a helping hand." In 1946, Ford Motor Company closed four village industries. On April 1, 1947, Henry Ford II made the decision to close five more village industries, including Nankin Mills. Henry Ford died six days later. In 1948, Nankin Mills ceased operations. (Courtesy of the Nankin Mills Interpretive Center Archives.)

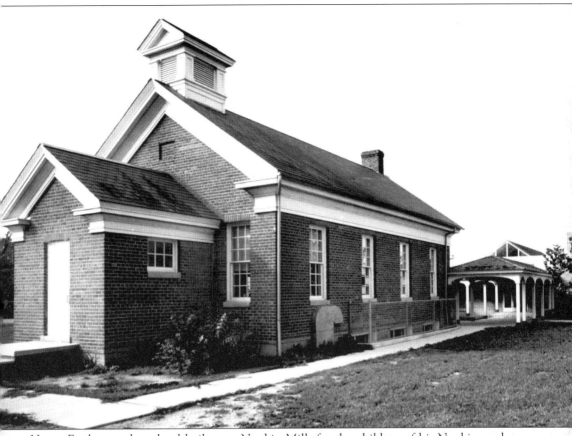

Henry Ford wanted a school built near Nankin Mills for the children of his Nankin workers. He decided to model the outside of his new school after the Perrinsville One-Room Schoolhouse, on what is today Warren Road, west of Merriman. The schoolhouse was called the Nankin Mills School, also known as the Ford School. The Nankin Mills School had indirect lighting, modern toilets, improved heating, and a basement. The school desks had swivel seats. Henry Ford went so far as to hire the teacher from Perrinsville One-Room Schoolhouse, Mildred Harris, to teach at the Nankin Mills School. (Courtesy of the Wayne Historical Museum.)

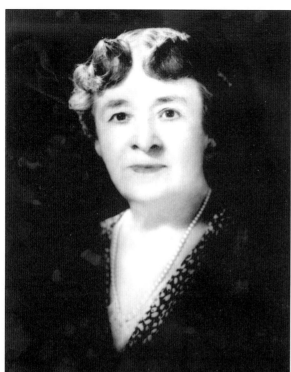

On a visit to the Nankin Mills School, Henry Ford's wife, Clara, used a white glove to look for dirt. When she ran her hand over a windowsill she found some dust. She left the glove on the windowsill to remind the janitor, a full-time employee of the school, to keep the building clean. (Courtesy of Ford Motor Company.)

Mrs. Frances (Ma) Sullivan, seated, was a "forelady" at Phoenix Mills, another of Henry Ford's village industries. (Courtesy of the Nankin Mills Interpretive Center Archives.)

Eight

THE NATURE CENTER

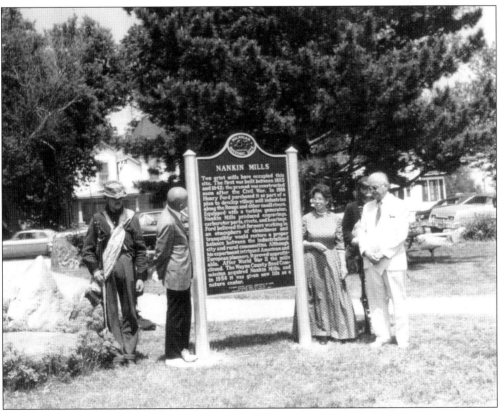

In 1977, a state historical marker was erected at the site of Nankin Mills, then a nature center. Its creator, Mary Ellsworth, stands to the right of the marker. She would later say of the nature center, "I started it from scratch . . . and I closed it up." (Courtesy of the Nankin Mills Interpretive Center Archives.)

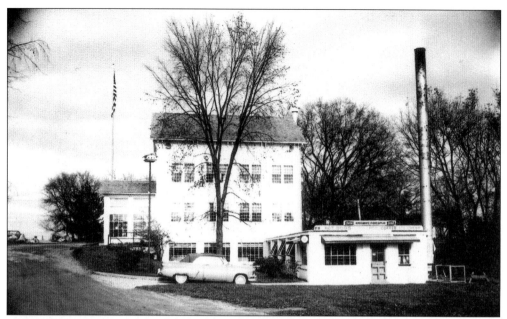

In the 1930s, the Ford stencil-making shop continued to grow. Henry Ford had a one-story annex built on the back of Nankin Mills. In 1948 Clara Ford sold Nankin Mills to the Wayne County Road Commission for $1. The annex became a concession stand. (Courtesy of the Nankin Mills Interpretive Center Archives.)

In 1956, Mary Ellsworth, a Michigan State University graduate, was hired by the Wayne County Road Commission to create a nature center. She said. "It was quite a challenge, but it was fun." (Courtesy of the Nankin Mills Interpretive Center Archives.)

In an interview, Mary Ellsworth said, "They gave me a building without heat, water or electricity. There was a pot-bellied stove down in the basement and I had to split wood the first winter to keep warm." (Courtesy of the Nankin Mills Interpretive Center Archives.)

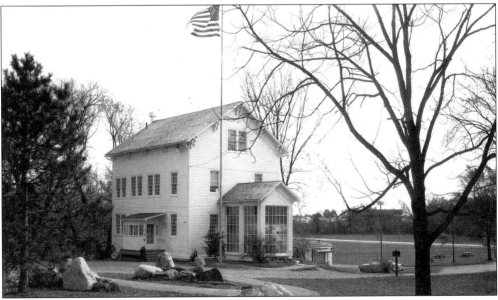

For two years, Mary collected exhibit materials and painted backgrounds for the many displays. She did not have a staff until just before the Nankin Mills Nature Center opened in 1958. During those first difficult months, neighborhood children aided Mary. (Courtesy of the Nankin Mills Interpretive Center Archives.)

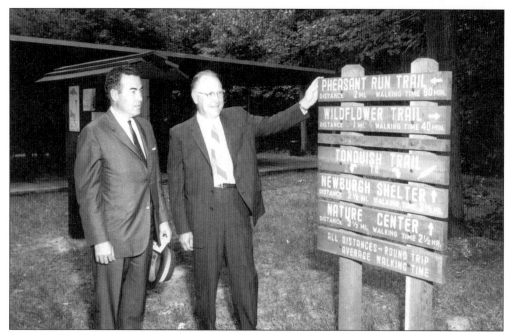

In 1958, Wayne County began acquiring about 500 acres of woodlands near Nankin Mills. Twelve miles of trails were marked. They led through groves of oak, hickory, and beech trees, as well as around marshes and meadows. The Holliday Nature Preserve was dedicated on July 1, 1964. Mary Ellsworth often led tours along these trails. Many of these tours were with school-aged children. (Courtesy of the Nankin Mills Interpretive Center Archives.)

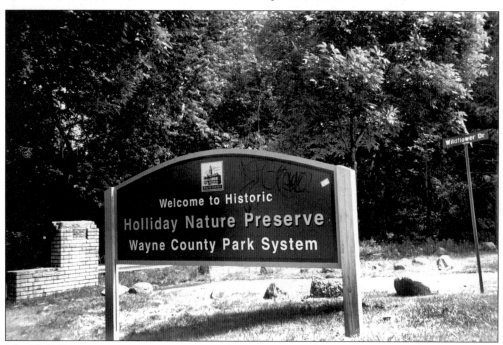

The Holliday Nature Preserve, named in honor of William P. Holliday, is home to a variety of flora and fauna, including foxes, deer, raccoons, and owls. (Courtesy of Daryl A. Bailey.)

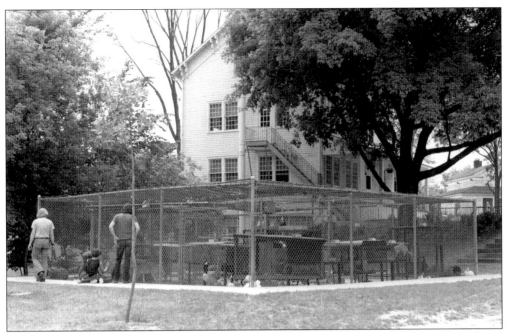

An animal compound was built next to the Nankin Mills Nature Center. Here, injured and orphaned animals were cared for. The goal was not to create a zoo, but to rehabilitate and restore the animals to their natural habitat. (Courtesy of the Nankin Mills Interpretive Center Archives.)

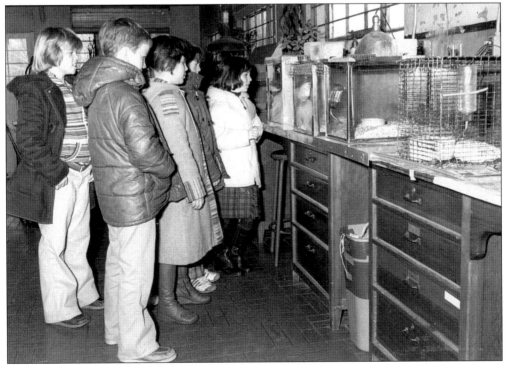

The Nankin Mills Nature Center had indoor animal cages so that visitors could observe small animals close-up. (Courtesy of the Nankin Mills Interpretive Center Archives.)

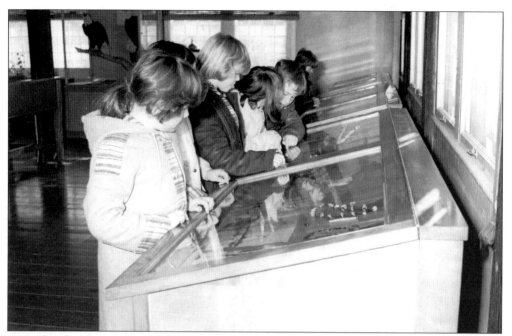

At its height, the Nankin Mills Nature Center attracted about 30,000 visitors a year. Here, children view items in the Native American exhibit. (Courtesy of the Nankin Mills Interpretive Center Archives.)

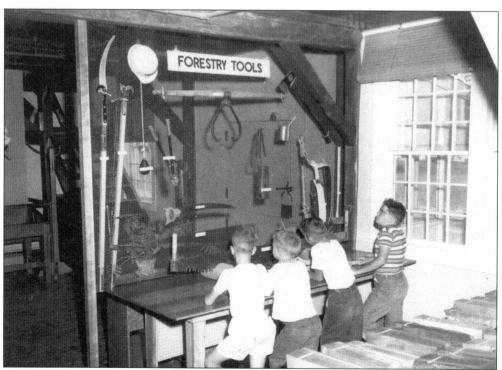

The forestry tools, exhibited here, awed children of all ages. (Courtesy of the Nankin Mills Interpretive Center Archives.)

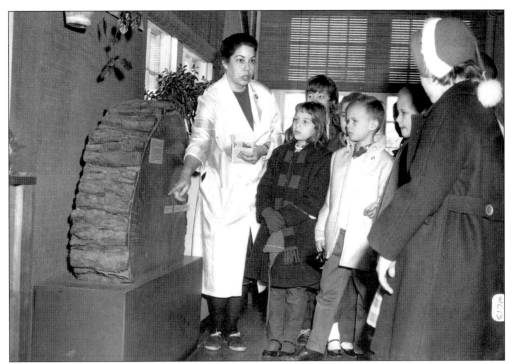

Pictured here are Mary Ellsworth and some children in front of her "Teaching Tree." (Courtesy of the Nankin Mills Interpretive Center Archives.)

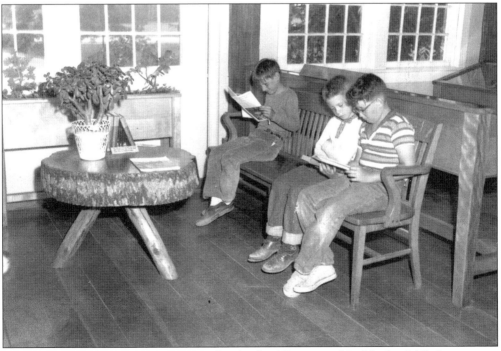

Children spend some quiet moments reading books. (Courtesy of the Nankin Mills Interpretive Center Archives.)

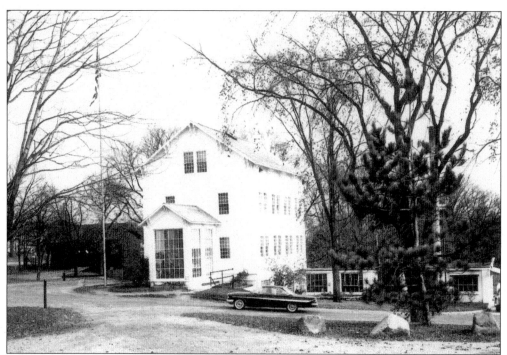

Sadly, all good things must come to an end, as it came to pass for the Nankin Mills Nature Center. In 1979, facing a budget crunch, Wayne County cut funding for the nature center. The job of closing the center fell upon its creator, Mary Ellsworth. (Courtesy of the Nankin Mills Interpretive Center Archives.)

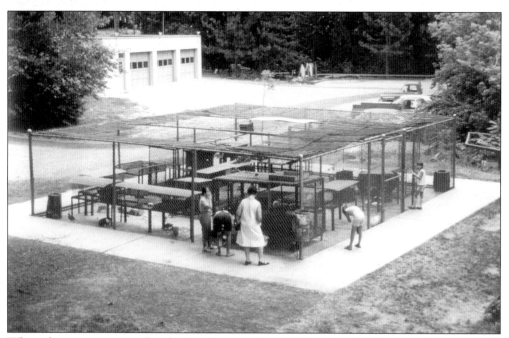

When the nature center closed, what happened to all the animals? The animals went to the Detroit Zoo. (Courtesy of the Nankin Mills Interpretive Center Archives.)

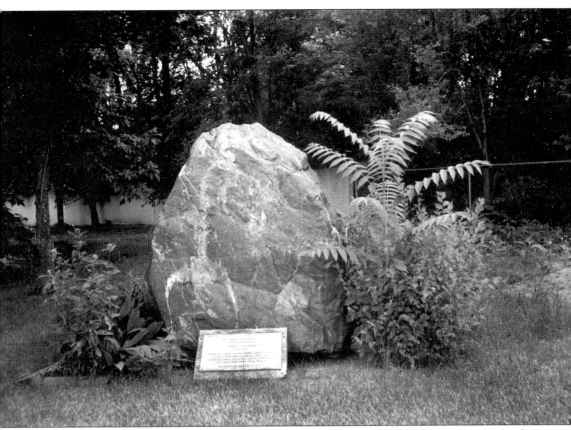

On January 28, 1987, Mary Ellsworth died at the age of 68. In the fall of 1988, the Westland Historical Commission established a memorial for Mary on the grounds of the Westland Historical Museum. The stone for her memorial came from the Nankin Mills area. The plaque, at the base of the memorial, reads in part, "Historian, Founder of the Wayne County Nature Center, Naturalist, Westland Historical Commissioner, and a True Beloved Friend of All People and Other Living Things." (Courtesy of Daryl A. Bailey.)

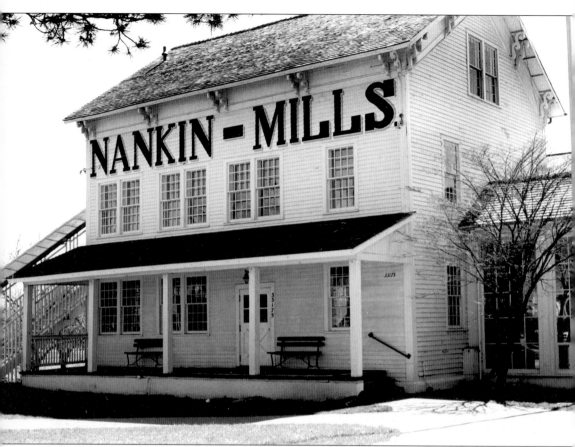

Today, Mary Ellsworth's legacy continues at the Nankin Mills Interpretive Center. After the close of the nature center, Nankin Mills fell into disrepair. It may have been lost forever if it had not been for the dedication of a group called the Friends of Nankin Mills. The Nankin Mills Interpretive Center Gala Premiere was on January 11, 2001. (Courtesy of Daryl A. Bailey.)

Nine
LEST WE FORGET

Built in 1942, Norwayne was a federal housing project. It was located between Palmer to the north, Wildwood to the west, Glenwood to the south, and Merriman to the east. Its 1,900 frame buildings housed about 8,000 people. These homes were for Army Aircorps personnel and factory workers engaged in the production of B-24 bombers at the Ford Willow Run Bomber Plant. (Courtesy of Daryl A. Bailey.)

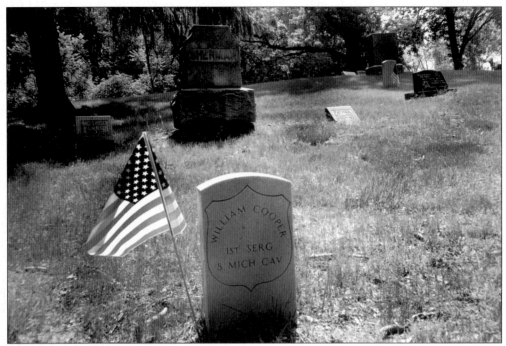

William Cooper served in the 8th Michigan Cavalry during the Civil War. The grave of this veteran is just one of the many decorated with an American flag every Memorial Day. (Courtesy of Daryl A. Bailey.)

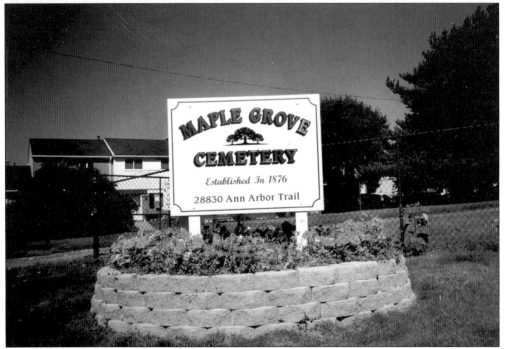

Maple Grove Cemetery is the final resting place for William Cooper and other notables in the area. (Courtesy of Daryl A. Bailey.)

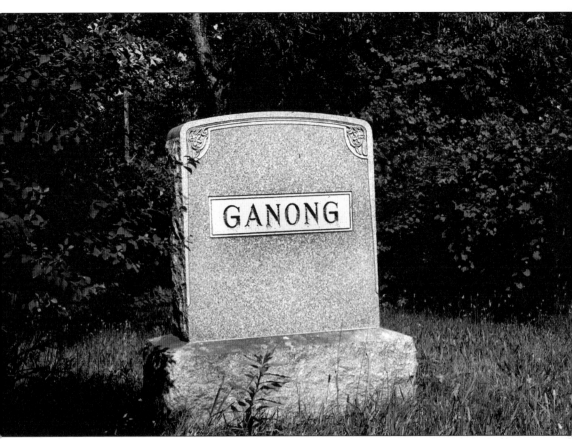

In the late 1800s, William Ganong set aside an acre of his land, " . . . as a final resting place for friends and loved ones." It was to be a mark of respect and a token of love for those who came after him. During its history, the Ganong Cemetery has gone through periods of neglect. It deserves to be preserved, because it is the final resting place for several early area pioneers. (Courtesy of Daryl A. Bailey.)

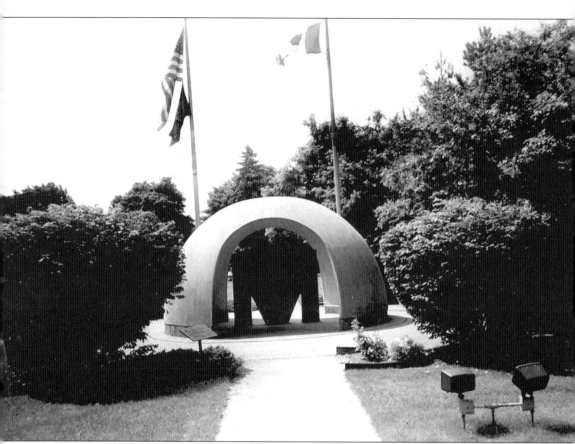

The Westland Vietnam Veterans Memorial was dedicated on May 25, 1987. Standing on the east lawn of the Westland City Hall, it honors the American Vietnam Veterans who, ". . . deserved the respect and recognition that they rightfully earned while on the battlefield defending our nation." (Courtesy of Daryl A. Bailey.)

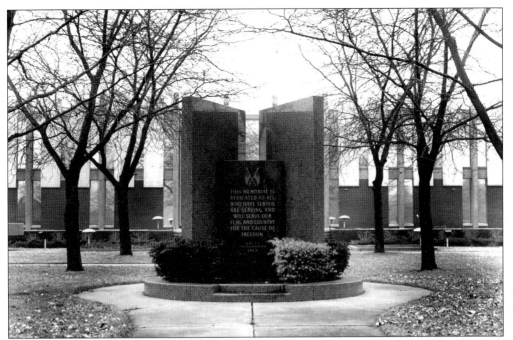

Dedicated on May 30, 1969, Westland's War Memorial stands in front of City Hall. It honors local veterans from all wars. (Courtesy of the Westland Community Relations Department.)

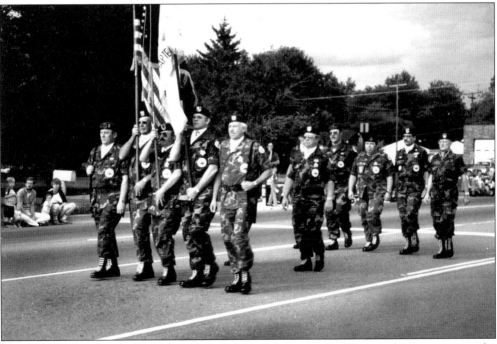

The City of Westland holds a Memorial Day Parade bi-annually. The parade route starts at the intersection Cherry Hill and Wayne Roads, travels north along Wayne Road, turns west on Ford Road, and ends at the Westland War Memorial, in front of the Westland City Hall. (Courtesy of the Westland Community Relations Department.)

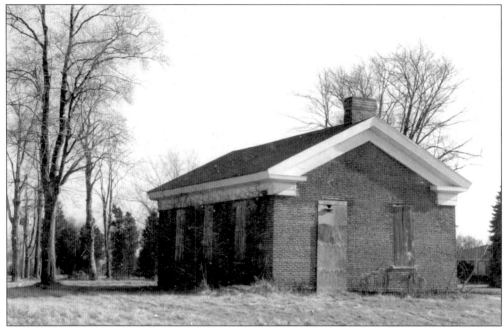

After the Perrinsville One-Room Schoolhouse closed in 1937, it became a Bible Church, but eventually fell into disrepair. In 1990, the City of Westland acquired the schoolhouse. With the aid of a State Equity Grant, the Westland Historical Commission and the Friends of the Westland Historical Museum began the effort to restore the building to its 1890s appearance. The rededication ceremony for the schoolhouse occurred on October 12, 1998. (Courtesy of Virginia Braun, Chairperson of the Perrinsville Restoration Committee.)

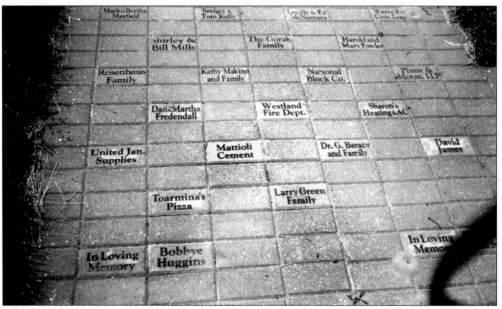

The Friends of the Westland Historical Museum sell bricks to raise funds for the maintenance of the Perrinsville One-Room Schoolhouse. Donors can purchase a brick with their name, that of a business, or as a memorial for a loved one. (Courtesy of Daryl A. Bailey.)

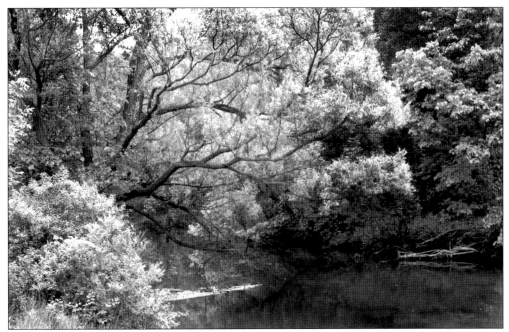

The Rouge River has played an important role in the history of Westland. The best land for farming was along its banks. The river provided power for saw and gristmills and it supported wildlife and fish that served as food for the first settlers. (Courtesy of the Westland Community Relations Department.)

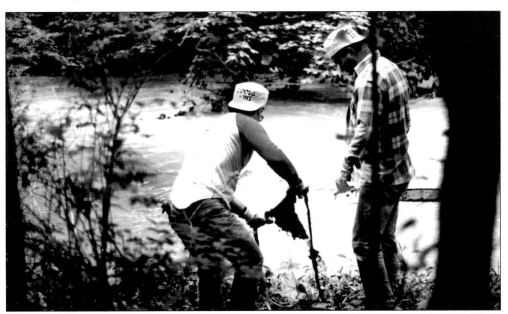

Sadly, industrial and human wastes contaminate portions of the Rouge River, and logs and other debris clog the waterway. Through the efforts of the Friends of the Rouge, the Holliday Nature Preserve Association, the City of Westland, and other volunteer groups and individuals, annual Rouge Rescue clean-up days are bringing back parts of this historical river. (Courtesy of the Westland Community Relations Department.)

On April 25, 1966, Thomas H. Brown was elected the first mayor of Westland. He received 6,979 votes, while his opponent, Ray C. Adams, received 3,673. He was involved in the creation of the Friends of the Westland Historical Museum and the Friends of Nankin Mills. Tom served as State Representative, Westland City Councilman, and Chairman of the Westland Historical Commission. (Courtesy of Dymphna Brown.)